POSTCARD HISTORY SERIES

New York City's
Financial District
IN VINTAGE POSTCARDS

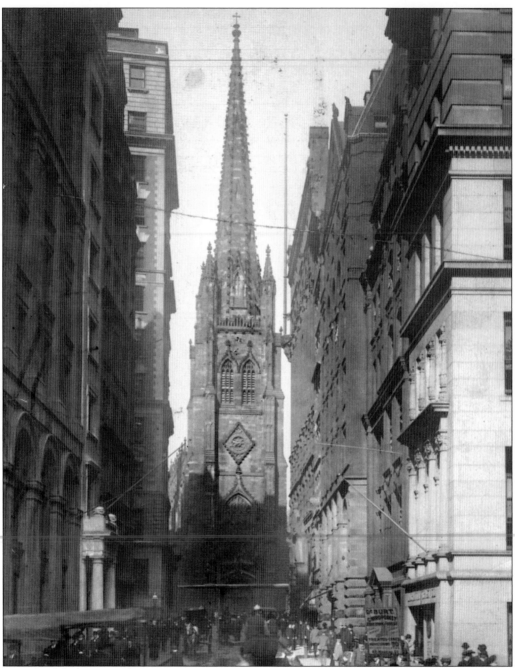

Viewed looking west, Richard Upjohn's Trinity Church, which is set on a direct axis with the center of Wall Street, is perhaps the best fixed image of New York's financial district. With its spire rising 280 feet and 5 inches (including its 6-foot cross), this building was once the tallest structure in the city and was a benchmark for the rapid rise of surrounding skyscrapers in the late 19th and early 20th centuries. Three of the four corners of Broad and Nassau Streets were transformed in the two decades after this *c.* 1904 photographic card was taken. (Please refer to pages 31, 32, and 35 for examples of this transformation.)

POSTCARD HISTORY SERIES

New York City's
Financial District
IN VINTAGE POSTCARDS

Randall Gabrielan

ARCADIA

Published by Arcadia Publishing,
an imprint of Tempus Publishing, Inc.
2 Cumberland Street
Charleston, SC 29401

Printed in Great Britain.

Library of Congress Catalog Card Number: 00-100871

For all general information contact Arcadia Publishing at:
Telephone 843-853-2070
Fax 843-853-0044
E-Mail sales@arcadiapublishing.com

For customer service and orders:
Toll-Free 1-888-313-2665

Visit us on the internet at http://www.arcadiaimages.com

I dedicate this book to John A. Campbell, one of my earliest friends and associates in the insurance brokerage business as well as one of my last. We met on opposite sides of a corridor in the downtown home of an ill-fated insurance company and took diverging paths. Decades later, Jack is the chief executive of a successful firm, while the author must be one of very few Chartered Property and Casualty Underwriters writing history. However, the fellowship and mutual concerns remain unchanged. Jack, it is a pleasure to recognize your character and accomplishments.

CONTENTS

ACKNOWLEDGMENTS

I thank and acknowledge the contributors who helped make this book. Gail Greig is an accomplished photographer and postcard publisher who helps keep the tradition of the artistic postcard alive. Her recent work made a significant difference in extending the time frame of this book. John Rhody, who has contributed to over 20 of the author's works, is always accessible at the outset of a project with meaningful examples. Thanks John. Photographer John Kowalak also maintains a postcard tradition—the photographic postcard. His work has an immediacy of feeling not often found in the commercially printed product. A second "Thanks, John." Joan Kay, one of New York's outstanding postcard personalities, made important contributions worthy of this special word of appreciation.

First-time contributors also deserve a special mention. Thanks to Saul Bolotsky and Stephen Zussman. Many thanks to all who have answered questions and to the other lenders of postcards, including: Barbara J. Booz, Moe Cuocci, Cynthia Harris, John McGrath, Timothy J. McMahon, Robert Pellegrini, Glenn Vogel, and Marion Wardell. And last, but not least, to Mary Bergeron of Indianapolis, Indiana's Holliday Park, for the contemporary image of the Bitter statues and to Rosemary Zimmerman of the Middletown Township Public Library (New Jersey) for tracking them down.

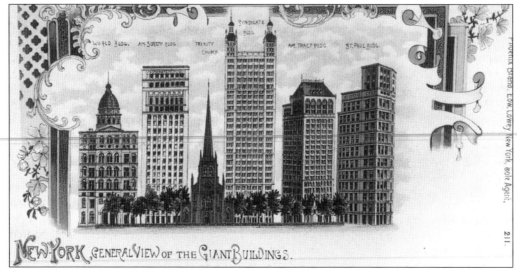

During the first third of the 20th century, a period that embraced the postcard era, downtown New York was transformed by the world's greatest collection of skyscrapers. Five 19th-century offices are shown in relation to Trinity Church's spire, once the most prominent landmark in New York City. Progressively higher buildings were rapidly erected in the years following this *c.* 1902 card. One suspects that few passers-by of the center office, better known as the Park Row Building (page123), realize that it once held the distinction of being the world's tallest office building. (Courtesy of Joan Kay.)

INTRODUCTION

The postcard was to communications at the beginning of the 20th century what the Internet is to this one; it was a relatively new idea taking hold like wildfire that revolutionized communication. The postcard contained a novel element. While words have been freely and quickly exchanged in various media over the past century, the postcard distributed pictures like nothing before them. At a time when book and newspaper photographic illustrations were only beginning to become widely circulated, the postcard quickly placed clear, colorful, inexpensive images in all parts of the country and the world. Postcards became an international collecting mania between 1905 and 1915, a period known as the postcard era.

The postcard era was an exciting and booming period in the development of New York. The five boroughs had recently consolidated (1898), new public buildings were rising, and the city's skyline was increasing in public consciousness by the rapidity of its change. The vast output of the time has led most postcard books to focus the early years of the 20th century. However, *New York City's Financial District* spans the entire century, albeit without even distribution and with the realization that the most dismal times of postcard production coincided with an almost two-decade period from about 1915 to 1932, when New York construction was at its most vibrant.

A brief history of the postcard, helpful for appreciating this volume, is presented by capsule summaries of the following recognized postcard periods:

The Private Mailing Card Era. Postcard use began as a practical matter after the Private Mailing Card Act of 1898, which effectively standardized postcard appearance. Their examples, which are not plentiful for New York, are typically imprinted on the back, or address side, with the slogan, "Private Mailing Card – Authorized by Act of Congress May 19, 1898."

The Postcard Era. Foreign manufacturers dominated the 1905–1915 period, especially the German manufacturers, whose lithography process produced most of the better cards. Photographers printed actual photographs on postcard-size printing paper, typically with the words "Post Card" printed on the back. This period is divided by legislation effective March 1, 1907 that permitted the writing of messages on the back, which had theretofore been reserved for the address. Their distinguishing mark is a vertical line in the middle of the address side, dividing the era into "undivided back" and "divided back" periods. High protective tariffs that began in 1909 steered the market to inferior American-made cards. This quality decrease, the waning of interest that follows any overheated collecting mania, and the onset of World War I brought the period to a close. The era is characterized by publishers with series of well-printed cards, including Rotograph, the Illustrated Post Card Company, and Raphael Tuck & Sons among others. Some publishers are mentioned in the captions as a matter of interest. Photographers became postcard publishers by printing pictures on postcard stock. Some such images were tantamount to the news photograph of the day.

The White Border Era. This period, generally defined as between 1915 and 1930, with overlaps known, is characterized by its often dismal, poorly printed cards surrounded by a narrow border of white space on all sides. Its inferior graphics represent the low point of postcard production. The period is redeemed by the realization that important places built in this time frame are often

known only on white border cards, including some of the great New York City office buildings. However, the large New York market was able to produce more photographic cards in this period than most other places.

The Linen Era. A new printing process prevailed in the period from 1930 to around 1950, one that permitted bright colors on an absorbent, rough-surfaced stock that had a look and feel characteristic of linen. A lack of clarity lessened their appeal for collectors, but the interest in linens has risen recently with their aging and with an appreciation for their frequently outlandish colors, as well as the travel and advertising topics popular in the linen era. New York City scenic linens are often of poor quality. However, the linen era was outstanding in the city for restaurant cards.

Chromes and the Modern Era. Printed color cards, often with the clarity of photographs, were introduced nationally *c.* 1940. New York examples contribute significantly to the past half-century's history. Their size varies from the standard 3.5 by 5.5 inches to the current Continental format, the approximate 4.25 by 5.75 inches, which is popular in Europe. Photographic postcards were also issued after 1915; at times, few hints exist for dating them.

Various other types and processes do not fit the widely accepted postcard categories. They include monochrome examples of various printing methods and the modern photographic card.

One use of this book is as a reader's guide to the streets of the financial district, in this instance an area liberally defined as Manhattan from Chambers Street south. The work is designed to flow geographically. Space and availability constraints do not permit illustrating every building of note, particularly the newer ones. However, there are many opportunities to compare what once stood and what has been added to numerous local sites.

One of the greatest research challenges of a building-oriented work is ascertaining height and number of stories, which, until one attempts to write, seems to be a straightforward matter. However, meritorious sources often conflict and even sources closer to construction dates do not prove definitive. Promotional excess, distortion for various purposes, and lack of common measuring points contribute to different depictions of these two matters. The author has sifted through many references, has made a best effort to accuracy in the matter, and takes responsibility for any shortcoming.

I have generally followed the historian's practice of using buildings' original names. Please accept any inconsistency with the few exceptions as literary license.

The author welcomes comments, criticism, or illustrations for future works and may be reached at 71 Fish Hawk Drive, Middletown, New Jersey 07748, (732) 671-2645.

One
THE BATTERY
SOUTH FERRY TO BATTERY PLACE

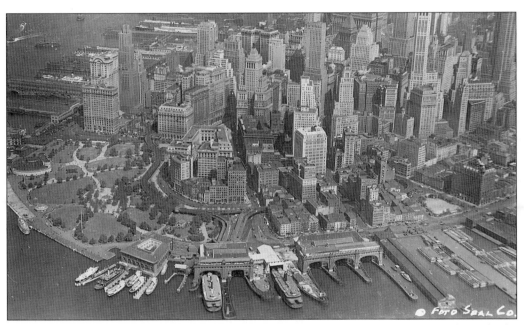

The idea of the New York skyline, if fixed in any viewer's mind, is present through the recollection of a first sighting or a favorite image. The skylines, of which there are many, are ever changing landscapes. The downtown vistas, seen when arriving via the historical maritime passage, are especially striking as they embrace the world's greatest collection of skyscrapers. This view of the financial district before the predominance of glass and steel buildings dates to *c.* 1940. The Whitehall Building (page 15) is at far left. Behind it stands the Downtown Athletic Club. The inverted U identifies the Custom House (page 22), and the dark cube to its right marks the Produce Exchange (page 20). Broadway begins at number 1, the Washington Building (page 14), left of the Custom House, which is seen here after its 1921 Neo-Classical remodeling. The two pyramids are the Standard Oil Building (page 24), above the Produce Exchange, and Bankers Trust (page 35) at the center top, standing in front of the massive Equitable Building (page 58). Note how the two elevated lines snake around the Battery. The east side line passes by Jeannette Park, over which the former Seamen's Church Institute (page 97) stands to the far right.

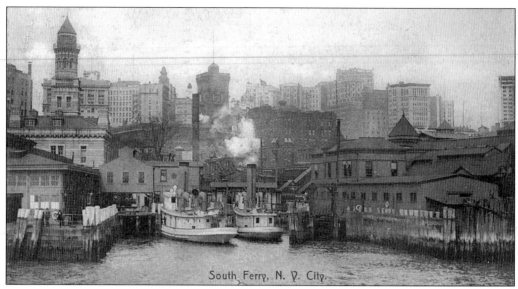

South Ferry, N. Y. City.

The first steam service between Manhattan and Staten Island began *c.* 1817, but records of early operators are obscure. The first vessels were single-ended steamboats, rather than double-ended ferryboats. The consolidated operations of various pioneer firms came to be controlled by the railroads. After some years of political struggle, the New York legislature amended the city's charter in 1903 to permit ferry operation, and the City of New York took over the Staten Island route in 1905. A greatly altered South Ferry is made recognizable by the towers of two no longer standing buildings: the Barge Office at left and the Produce Exchange above the two boats. However, the best view of the pier to Staten Island is the double-berth terminal, seen to the left of center in the bottom of the preceding picture

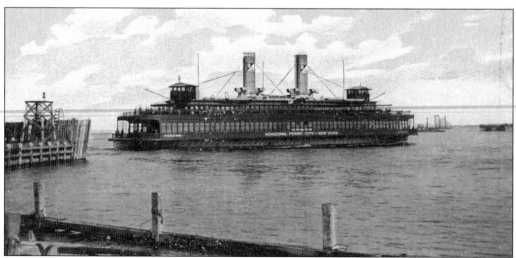

After the city ordered a fleet of five new ferryboats in 1904, the Maryland Steel Company won a bid for vessels designed by Millard & Maclean of New York. The company subcontracted one of the 246-foot, double-deck boats and built the other four at its yard in Sparrows Point, Maryland. The vessels, named for the five boroughs of New York, came to be known as the borough class and were launched in April 1905. The 46-foot-wide craft had two boiler rooms, one on each side of the engine room in the center of the boat. The pictured *Queens* was scrapped in 1947.

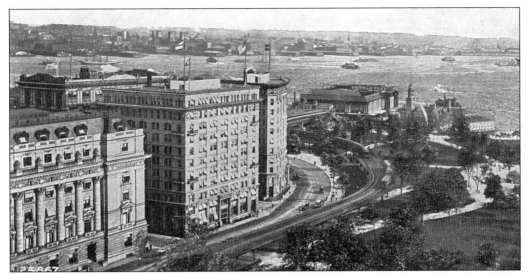

The southwest corner of the Custom House, seen at left, is the only still-standing reference in this *c.* 1910 streetscape. A glimpse of the Maritime Building appears above it. The Battery Park Building, designed by Clinton & Russell, is below the Custom House on the south side of Bridge Street; they are separated from the Cheeseborough Building to the south of it by Pearl Street. The ferry terminal was rebuilt and the barge office (page 16) to its right was demolished. The two office buildings were replaced by Battery Park Plaza and State Street Plaza, respectively, in the early 1970s. Brooklyn is seen in the background.

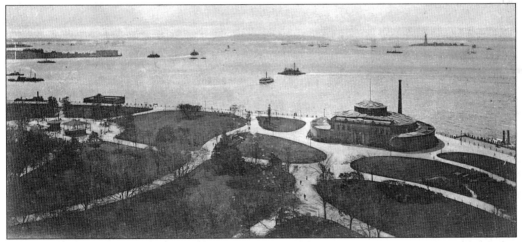

Erected on an artificial island about 100 yards off the Battery, Castle Clinton was built between 1808 and 1811 as a defensive fortification against potential naval invaders. Initially called the West Battery, it was renamed in 1815 for DeWitt Clinton, a former mayor of the city and future governor of New York. Its design is attributed to Lt. Col. Jonathan Williams and John McComb Jr., who is probably responsible only for the entrance. Military use ended in 1821 and the place was ceded to New York City in 1823. The city leased the former fort for public entertainment in 1824 and renamed it Castle Garden. The roof was erected in the 1840s. Castle Garden began a new incarnation as an immigrant landing depot in 1855, shortly after landfill connected the building to the mainland.

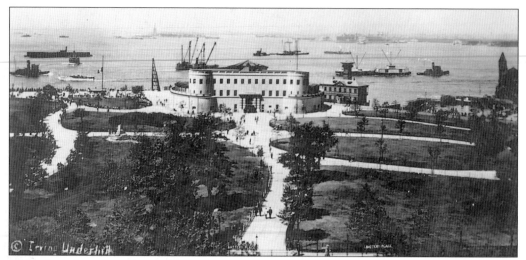

More than 8 million immigrants passed through Castle Garden between 1855 and 1889, amounting to two out of every three arrivals to the United States. Additional buildings were erected outside the former fort in 1882 as the number of immigrants increased. The last of them went through on April 18, 1890, after which the Barge Office became a temporary depot pending the opening of Ellis Island on January 1, 1892. Alterations by McKim, Mead & White, c. 1928, included a gray fence covering the brownstone walls and the erection of the three-story structure behind the east wall. The National Park Service restored Castle Clinton to its 19th century appearance and reopened it in the summer of 1975 after it had been closed for 34 years.

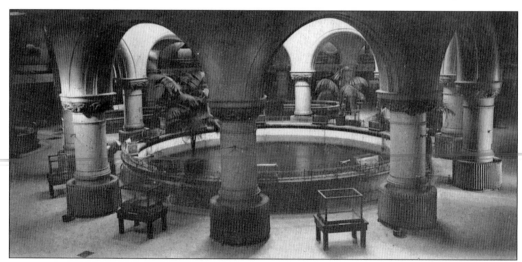

Castle Garden was remodeled as the New York Aquarium and opened December 10, 1896, a time when aquatic study in the United States was unadvanced. Originally operated by the city, the aquarium initially specialized in examples from New York area waters, but in time it expanded the collection greatly. The New York Zoological Society assumed management in 1902. Always popular and often crowded, the fixed walls of the aquarium precluded expansion. It was forced to close in 1941 when Robert Moses sought to clear the site for a bridge to Brooklyn. The aquarium operated at a temporary facility at the Bronx Zoo from 1942 until the spring of 1957, when the present aquarium in Brooklyn was opened. The second story of Castle Garden was removed during restoration.

John Ericsson, a naval engineer born in Sweden in 1803, studied in London and immigrated to the United States, where he helped develop steam propulsion. The iron-clad *Monitor*, which he built for the U.S. Navy, gained him notoriety and additional business. Ericsson lived at 36 Beach Street in New York between 1864 and 1889, the year he died. This heroic-sized bronze statue by sculptor Jonathan S. Hartley was unveiled in Battery Park in 1903. Ericsson faces the water, holding a model of the *Monitor* in his left hand. One of four bronze reliefs on base designed by F.E. Wallis shows his ship in its famed Civil War battle with the *Merrimac.*

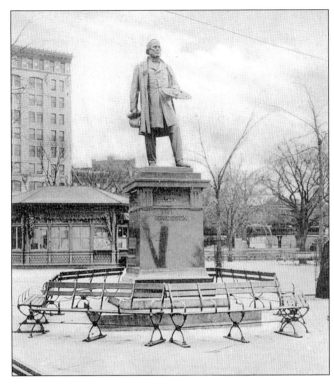

The facade of the Church of Our Lady of the Rosary at 7 State Street belonged to the former James Watson house. It had been built in two sections with the 1793 Georgian section on the east (right). Architect John McComb Jr. is attributed with the design of the 1806 Federal-style expansion that included original Ionic columns. The house, which follows the curve of the street, is the last survivor of a once fashionable residential area. The Mission of Our Lady of the Rosary (founded elsewhere) used the place well into the 20th century as a home for Irish immigrant girls. The former mission is now a separate parish, dedicated as a shrine to America's first native-born saint, St. Elizabeth Ann (Bayley) Seton, who was born in New York in 1774 (died 1821). She founded a Roman Catholic orphan asylum.

13

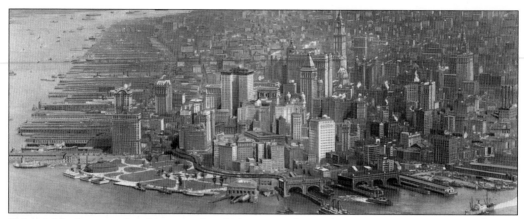

This aerial photograph taken *c.* early 1915, extraordinary for its clarity, shows change when compared with that on page nine. The Whitehall Building at left is a constant, but the Washington Building to the elevated line, had not yet been remodeled. The West Street Building (page 116) between them above, is obscured by later construction on page 9. The Adams Express Building (page 25) at 61 Broadway, notable for its visibility from the water, is also more prominent at center. Two prominent towers are visible, belonging to the Singer Building (page 62) and Woolworth's (page 70); the latter marks the northerly limit of the skyscraper district, while the pyramidal roof of the Bankers Trust Building (page 35) is between them. John Street is hardly distinguishable, having none of the 1920s construction that created its present character. It is identifiable here only by the power-generating stacks at far right. To their left, the Municipal Building (page 126–27) marks the northern boundary of this book.

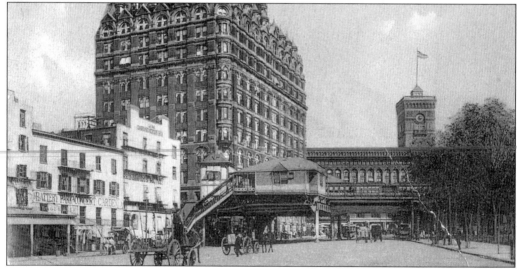

The Washington Building Company, organized by Cyrus W. Field, erected its namesake 178-foot office building between 1882 and 1885 at 1 Broadway on a 17,000-square-foot lot. It was bordered by Battery Place and Greenwich Street, the former site of the Washington Hotel (the former Kennedy mansion). Edward H. Kendall won a competition designing a ten-story Queen Anne-style building on a crucially sited location. The two-story mansard- and lighthouse-influenced tower (see page 21) was added in 1887, in part to enhance its visual impact from the harbor. Seen on a 1905 Rotograph card, the Washington Building was rebuilt in 1921 (as seen opposite). The Produce Exchange is in the background.

The Whitehall Building at 17 Battery Place was built in three major segments. Designed by Henry J. Hardenburgh, the original 20-story, 250-feet-high building faces Battery Place. It was completed in 1903. When the pictured 32-story, 416-foot-high extension (designed by Clinton & Russell) was added in 1911, the combined building was believed to be the largest office in the world by area. The shading in the 1911 Irving Underhill postcard reflects the structure's multicolored bricks. A 22-story, glass and steel section was added between the north and east facades of the 1903 and 1911 buildings, respectively. Long one of the best-known addresses in the maritime field, plans were announced prior to publication to convert over half of the space to apartments. The two pictured buildings appear unchanged; the block at right, east of Washington Street, is now filled by a ventilation tower of the Brooklyn–Battery Tunnel.

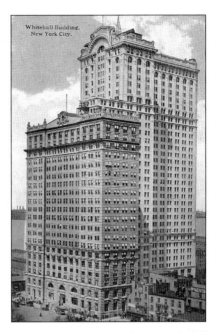

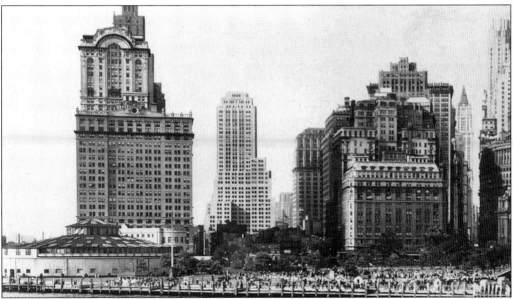

Looking north from the Battery, this *c.* 1940s view depicts the Whitehall Building at left, which obscures the barely visible 534-foot Downtown Athletic Club that was completed in 1930. L.A. Goldstone designed the 38-floor, 450-foot-high building located at 19 Rector Street on the southeast corner of Washington Street (center). The Downtown Athletic Club was completed in 1930. It faces 2 Rector Street, which was completed in 1906 and remained the only substantial building on that street for a long time. The Washington Building (right foreground) was reconstructed between 1919 and 1921 in a Neo-Classical style by architect W.B. Chambers and renamed for the International Mercantile Marine, a combination of shipping firms organized by J.P. Morgan in 1902. That firm, which evolved into the United States Lines, used the premises as a booking office. Note the maritime ornaments on the facade.

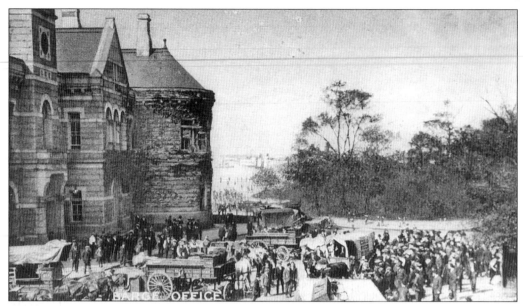

The United States Revenue Barge Office stood on the shore at the Battery, west of the ferry terminals. It served as an office for customs inspectors and housed a sailors' dispensary. Built in 1880, the pictured office was demolished in 1911, following the opening of the Custom House. The postcard was part of a historical series Ezra Meeker published for schools, libraries, the home, and collectors. (Courtesy of Joan Kay.)

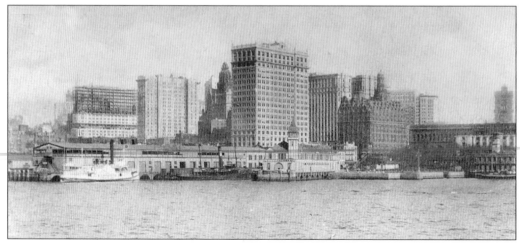

This 1905 Rotograph postcard of the Battery is included for its view of Pier A (center) as most other subjects in it are shown elsewhere, from the Trinity Building under construction (page 54), at left, to the Produce Exchange (page 20), at right. Designed by George S. Greeve Jr., chief engineer of New York City's Department of Docks and Ferries, the pier was completed in 1886. It was built on a masonry foundation that was unusual for local piers. It is 285-feet long and 45-feet wide and clad in wood frame and sheet metal that has been repaired and replaced over its century-plus existence. Pier A, which has been undergoing restoration for years, will open to new shops, restaurants, and a tourist office in the near future. Next to the construction project is the rarely seen south elevation of the Empire Building (page 23), which was later obscured by other buildings. (Courtesy of Moe Cuocci.)

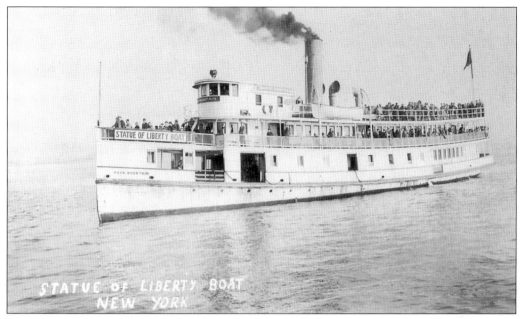

Excursion water travel began in the sail era by the early 19th century. A number of operators sent craft to a variety of destinations. Liberty Island, or Bedloes Island as it was known at the time of this *c.* 1930 photographic postcard, was a heavily trafficked route.

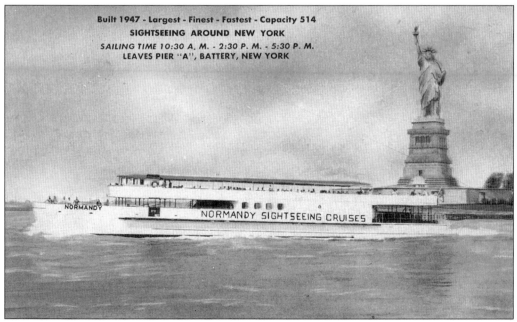

Built 1947 - Largest - Finest - Fastest - Capacity 514
SIGHTSEEING AROUND NEW YORK
SAILING TIME 10:30 A. M. - 2:30 P. M. - 5:30 P. M.
LEAVES PIER "A", BATTERY, NEW YORK

NORMANDY SIGHTSEEING CRUISES

In 1945, several excursion lines operating in city waters were merged into the Circle Line, the longtime operator of the route circling Manhattan. Their boats now leave from a West Forty-third Street pier on a trip that could be taken from the Battery in the late 1940s. The postcard is a late example of the linen type.

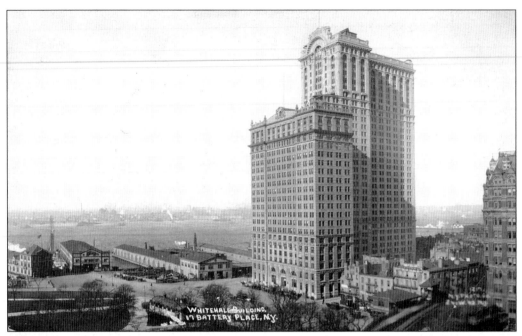

This *c.* 1912 photographic postcard shows the Whitehall Building in its relationship to the water. The partial view of Pier A, at far left, shows a new facade built in 1903 following a 50-foot extension of its shed on the shore side. Note the view looking down at the Ninth Avenue Elevated. This image was probably photographed from the roof of the Custom House. Battery Place was a terminus of the first test–elevated train in 1867; its course along Greenwich Street north to Cortlandt Street was incorporated into the aforementioned line.

An office construction boom from the late 1960s through the early 1970s reshaped the Battery landscape. The 1969 One New York Plaza, designed by William Lescaze & Associates, stands over the 1906–1909 Beaux-Arts-style ferry terminal. Note the Coast Guard Governors Island ferry docked. Adjacent to One New York Plaza is 125 Broad Street. Next to 125 Broad Street is the huge 55 Water Street building, designed by Emery Roth & Sons; it was the largest private office building in the world (by area) when completed in 1972. The two dark cubes at left are 1 State Street Plaza, front, and 1 Battery Park Plaza behind it. The two are "separated" today by the prominent curved glass facade of 17 State Street. The Whitehall Building (page 15) is at the far left over the present Staten Island Ferry Terminal.

18

Two
BOWLING GREEN
BROADWAY TO RECTOR STREET

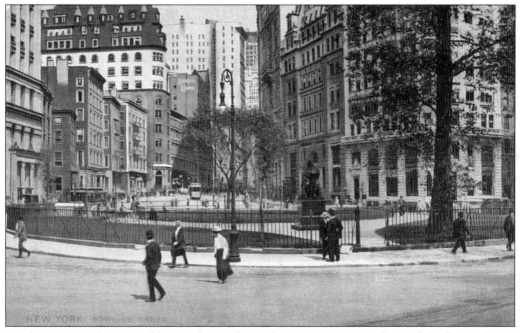

Bowling Green, the city's oldest park, was formerly an open space in front of the fort at the tip of Manhattan that marked its earliest settlement. Land to the south is largely fill. Known earlier as the Parade, the ground was leased as a bowling green in 1733. A statue of King George III, erected here in 1770, was torn down in 1776. The iron railing, placed here in 1771, is still standing. The statue of Abraham de Peyster, erected in 1896, was moved to Hanover Square. The low-rise buildings at left were replaced by the Cunard Building (page 25); the 1890 Columbia Building, designed by Youngs & Cable, stands over them. Designed by Ernest Flagg, the 1905 New York Produce Exchange Bank on the northeast corner of Broadway and Beaver Street is seen at right.

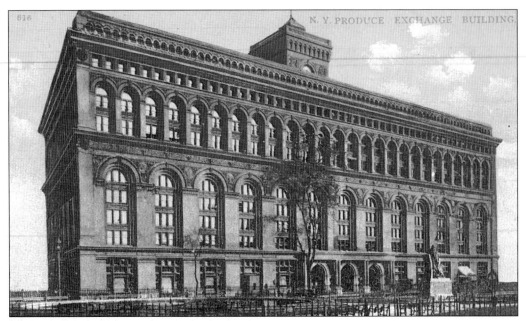

This home of the New York Produce Exchange (chartered in 1862) was one of the city's finest commercial buildings when erected in 1884. The Italian Renaissance Revival, Philadelphia-brick, and terra cotta structure was designed by George B. Post & Company and stood at 2 Broadway. Notice the arched windows, which doubled in number at each level. The 11-story, 200-foot-high tower on the east facade was a popular vantage for photographers. The 230- by 144-foot trading floor, once the largest of any exchange, took up most of the second story; it was covered by a vast skylight 60 feet overhead. The Produce Exchange was demolished in 1957 and replaced by the office building now on the site.

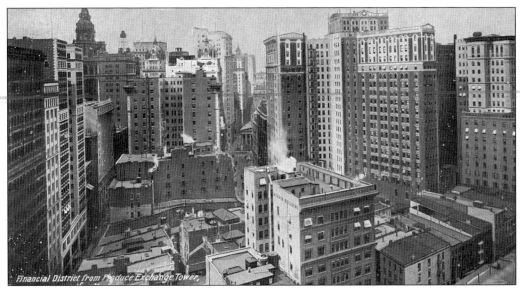

Financial District from Produce Exchange Tower.

A view north from the Produce Exchange shows the Sub-Treasury in the center background, Beaver Street at bottom, the rears of offices at the sides, Broad Street at right, and Broadway at left. The tower at left belongs to the Manhattan Life Building at 64–66 Broadway.

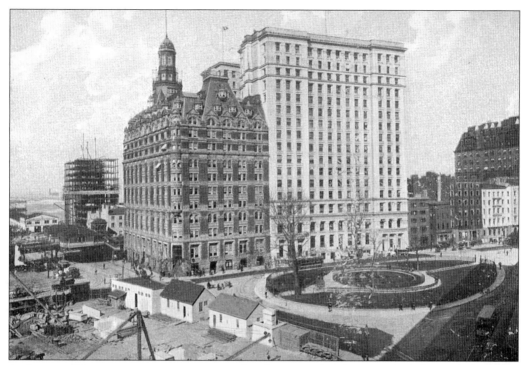

A Custom House construction site in the foreground, photographed from the present location of its stairs, is pictured with Bowling Green and its environs. The incomplete skeleton of the Whitehall Building (page 15) dates the picture to *c.* 1902, as that building was completed the following year. The Washington (left) and Bowling Green buildings provide extant points of reference, even though the former is now unrecognizable after its 1921 Neo-Classical remodeling.

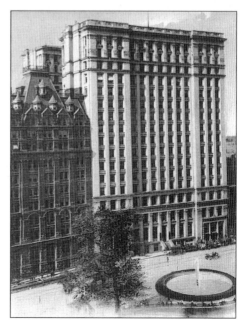

The 17-story, 229-foot-high Bowling Green Building at 11 Broadway was the largest in the city when built by Spencer Trask from 1895 to 1898. The Scottish-born architects William and George Audsley described their design influence as "Hellenic Renaissance." The limestone-clad, terra cotta–trimmed office has a three segment Grecian design form that resembles a base, shaft, and capital in the manner of a column. The facade is unchanged from the 1905 Rotograph postcard. A memorial plaque now north of the fountain recognizes the generosity of George T. Delacorte in supporting the 1977 restoration of Bowling Green.

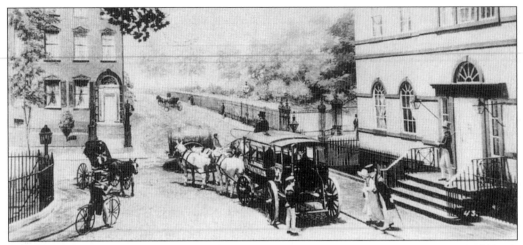

Many early New York stage and horse-drawn public vehicles ended runs in the areas of South Ferry or the Battery. Illustrations of historic prints extend back the time frame that postcards covered. One example is this Museum of the City of New York issue showing an 1831 Bowling Green scene of the "first omnibus." (Courtesy of Stephen Zussman.)

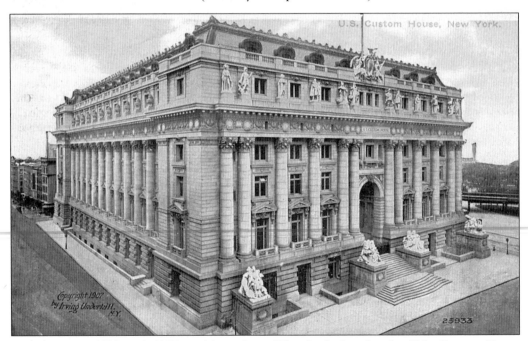

Built between 1899 and 1907, architect Cass Gilbert's design for the U.S. Custom House produced New York's greatest Beaux-Arts building. Facing Bowling Green, the picture also shows the east elevation of the building on Whitehall Street. The symmetrical plan grants an enormous interior space for its seven stories. The building is richly decorated with sculpture, notably the four large white limestone representations of the continents by Daniel Chester French and the 12 figures over a cornice sill representing historically successful trading nations and city-states. The splendor of the structure reflects the time when custom duties were the national government's most important source of revenue. The exterior is unchanged for the building's present occupancy by the Smithsonian National Museum of the American Indian.

 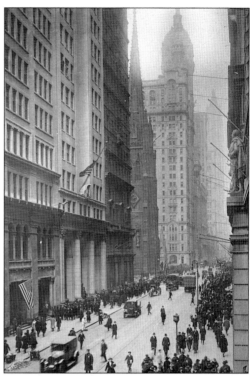

Broadway, looking south, provides a glimpse, above left, of a briefly existing, but historically significant structure, the Tower Building, which stood at 50 Broadway from 1889 to 1914. The 11-story, 150-foot building, designed by Bradford Lee Gilbert, was the first to employ a load-bearing steel skeleton, giving it claim as New York's first skyscraper. This *c.* 1920s photographic postcard of the west side of Broadway, above right, shows a glimpse of several buildings, including the Adams Express Building (page 25) at left and the book's only view of the adjacent 1917 American Express Building at 65 Broadway, designed by Renwick, Aspinwall & Tucker.

The 1898 Empire Building at 71 Broadway, the southwest corner with Rector Street, placed a 20-story, 293-foot-high building on a 78- by 223-foot lot opposite the Trinity Churchyard, visible at right. The Neo-Classical building, built by Marc Eidlitz & Son and designed by Kimball & Thompson, contrasts with the Gothic Trinity and the U.S. Realty buildings that Kimball designed for the north side of the Trinity yard (page 55). The Broadway entrance is in the form of a triumphal arch. Note the eagles on the globes of the paired columns aside the main arch. Known for many years for the longtime owner, the United States Steel Company, the office was converted to residential use in 1998. The exterior was maintained unchanged.
Pictured *c.* 1905, a glimpse of the Empire Building is also at top right.

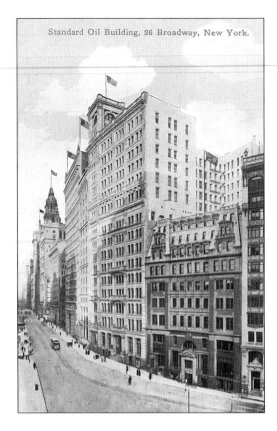

Standard Oil Building, 26 Broadway, New York.

Ebenezer L. Roberts designed the origins of the Standard Oil Building that was completed in 1886. The nine-story structure can be seen below the cornice line, just above the Welles Building at right. Built in 1882, the latter was designed by G.R. and R.G. Shaw. Pictured here *c.* 1910, when it was the Seaboard Bank, the building shows a new classical entrance. An 1896 expansion by Kimball & Thompson placed the upper six stories on the original building and added a narrow 19-story addition to the north. That firm also designed the 19-story Manhattan Life Insurance Company Building at 64–66 Broadway, which soared 350 feet to the top of the dome, visible in the background. Standard Oil would expand again southward to the Beaver Street corner (page 19).

The 1922–1926 southern expansion of the Standard Oil Building, designed by Carrere & Hastings with Shreve, Lamb & Blake, involved four construction segments on an irregular lot that extended to Beaver Street and over to New Street as the space became available. Thomas Hastings' classical design achieved a sculptural power that marked the structure a strong entrance to Broadway. Atop the 27-story, 505-foot-high building is a stepped pyramid roof on a tower, topped with an enormous oil lamp. The setting of the tower at an angle to the base increased the building's visibility from the harbor. The light court on Beaver Street, seen opposite the Produce Exchange, was built around a Childs restaurant that refused to sell its lease. This *c.* 1930 monochrome postcard shows that final space in the shadow, where the final piece was built when the barely visible old structure was removed. Above the subway entrance in the lower right corner is one of the statues standing in front of the Custom House.

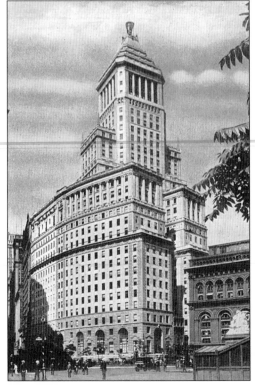

One of New York's grandest interiors, Cunard's Great Hall functioned as a ticket office and filled much of the first floor of their namesake 22-story office building at 25 Broadway. Completed in 1921 and designed by Benjamin Wistar Morris with Carrere & Hastings consulting architects, the Renaissance-style office addressed the 1916 zoning law without conspicuous setbacks. Cunard left in 1968. The hall, which is entered through the three central arches, has been filled by the Bowling Green Station Post Office since the mid-1970s; the occupancy mars the ability to view the art and ceiling frescoes, most with nautical themes, that richly decorate the vast space. The building, which runs through the block to Greenwich Street, and its interior were designated a New York City landmark in 1995. The New York City Police Museum opened on the second floor in January 2000.

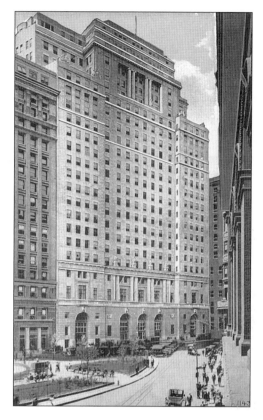

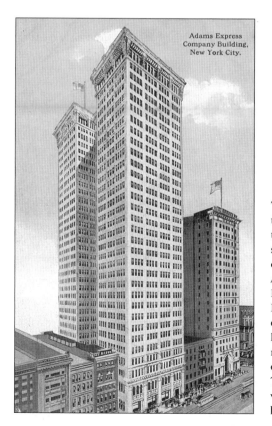

Adams Express Company Building, New York City.

The Adams Express Company Building appears to be larger in illustration than the view from the front of its 61 Broadway facade would suggest; this effect is created by the picture depicting its 209-foot length on Exchange Alley, a narrow side street earlier known as Tin Pot Alley. Completed in 1914 to a design by Francis H. Kimball, its white glazed southern exposure was more conspicuous to ocean liners entering the harbor than many of the nearby towers. Adams Express was consolidated in the Railway Express Agency. The building has changed little, except that the windows on the first two stories have been reconfigured.

25

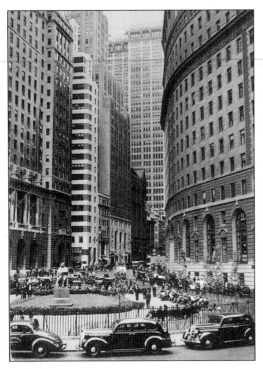

The narrow Art Deco round-cornered office at 29 Broadway, the northwest corner of Morris Street, was completed in 1931 on the site of the Columbia Building (page 19), which was designed by Sloan & Robertson. The light bands, seen in this *c.* 1940 monochrome, were created by alternating sections of white and dark gray bricks. The 30-story building fills an oddly shaped lot that widens as it runs through the block to Trinity Place. The tall building to the right of it is No. 39, the 1928 Fred F. French Broadway Building that was designed by Cross and Cross. The Adams Express Building (page 25) and the Standard Oil Building (page 24) are in the background and at right, respectively. The Bowling Green Park shows its re-landscaped appearance finished for the 1939 World's Fair.

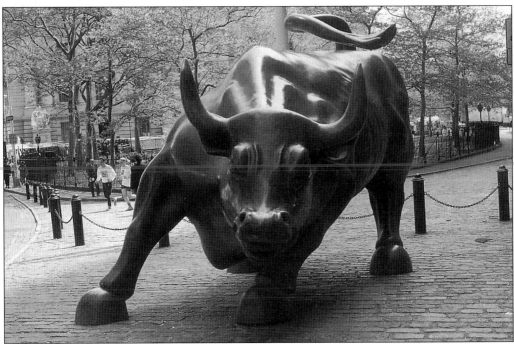

Charging Bull by sculptor Arturo DiModica was mounted at the north end of Bowling Green, *c.* 1989. The artist believed the image of the large animal in motion reflected the energy of the American people. The reader is brought face-to-face with the huge sculpture through the lens of Gail Greig.

Three

WALL AND BROAD STREETS

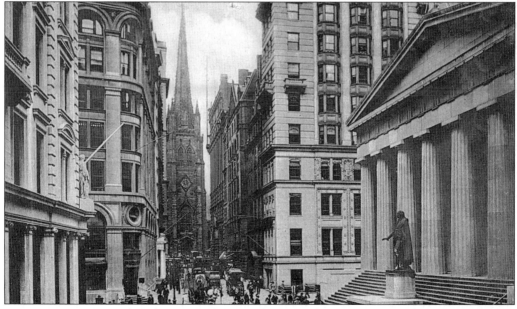

Wall Street, looking west *c.* 1905, is the familiar image fixed in our collective memory as the quintessential representation of the financial district. Trinity Church (page 52) and Federal Hall (page 29) at right are two constants in a vicinity of high-valued real estate that was markedly transformed in the first quarter of the 20th century, a process outlined in detail in these pages. The three other structures at the juncture of Broad Street are, from left to right, the Drexel Building (page 30), the Wilks Building (page 30), and the Gillender Building (page 34).

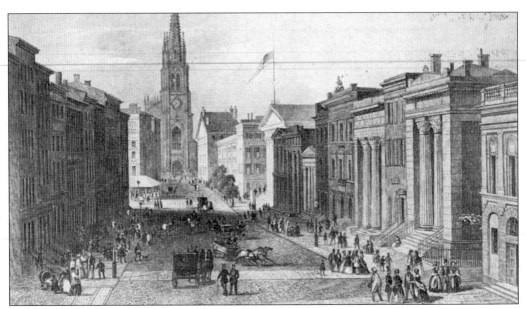

A historic print on a *c.* mid-20th-century postcard depicts Wall Street looking west from William Street in 1852. Federal Hall is under the flag. The image is a reminder that the 1846 Trinity Church dominated the landscape for decades until load-bearing steel frameworks and reliable elevator service sent office buildings soaring skyward in the late-19th-century. In walk-up buildings, stories above the second were essentially unrentable. The fine Greek Revival structure on the west side of William Street, at right, was the 1835 Bank of America, replaced in 1889 by the nine-story structure seen on page 37.

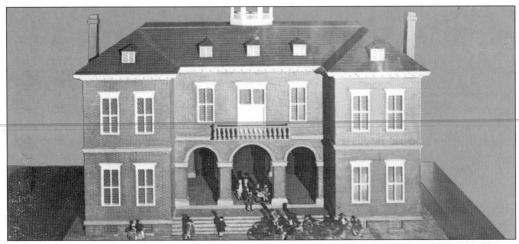

This chrome postcard pictures a model of the second New York City Hall, built on the northeast corner of Wall and Nassau Streets in 1703. The image is based on a drawing that David Grim did from memory in 1818. The structure, typical of English-influenced public buildings of its time, contained the then-usual governmental facilities, reportedly including a jail in the garret and a dungeon in the cellar. A third floor was added *c.* 1745. A replica of the building was erected in Bryant Park for the 1932 Washington bicentennial. The building served as the seat of national government from 1789 to 1790, being renamed Federal Hall. It reverted to City Hall use in 1790 and was demolished in 1812 when the present City Hall (page 118) was built.

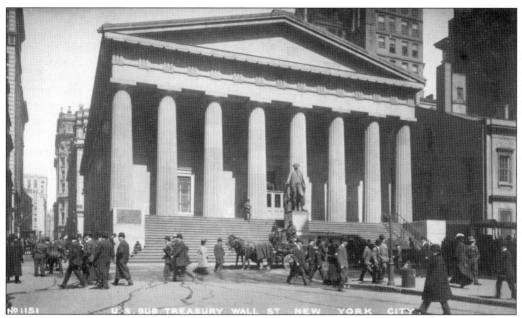

The U.S. Treasury Department erected a custom house on the early City Hall site, built between 1834 and 1842. Its design was the work of Ithiel Town, Alexander Jackson Davis, John Frazee, and Samuel Thompson. This Greek Revival building, perhaps the finest temple-form example in the city, served as a custom house until 1862, when it became the Sub-Treasury, a name at times used in lieu of its official one, the Federal Hall National Memorial. Federal offices filled the building from 1920 to 1939, when it was taken over by the National Park Service, which continues to maintain it as a museum. The bronze tablet at left is a commemoration of the acquisition of the Northwest Territory; one that portrays Washington praying was added at right. A glimpse of the Assay office is at right.

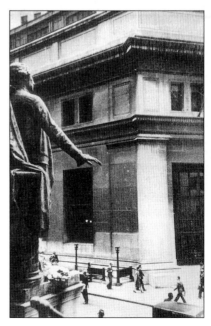

George Washington took his oath of office as president here in 1789, making the site one of the most significant in early American history. This 13.5-foot bronze statue of him by John Quincy Adams Ward was erected on a 6-foot pedestal on November 26, 1883, pursuant to an act of Congress at the request of the New York Chamber of Commerce. Ward (1830–1910) moved to New York City in 1861 and, as one of the few skilled native-born sculptors of his time, he became dominant in the field of public sculpture as interest in that art grew in the post–Civil War period. The base is an additional eight feet over the sidewalk. The view on this *c.* 1930s monochrome postcard overlooks the Morgan building.

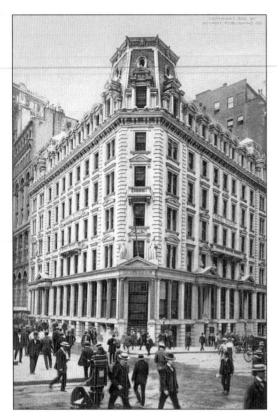

The Second Empire–style Drexel Building, located at the southeast corner of Wall and Broad Streets, was erected in 1872 shortly before the merger of Drexel & Company with the interests of Junius S. Morgan and his son, J. Pierrepont Morgan. Later construction around it obscures the fact that the building, designed by Arthur Gilman, was large for its time; it was on a sizable lot and dwarfed its surroundings, quite unlike its replacement. The Drexel Building was demolished for the erection of the 1914 building opposite.

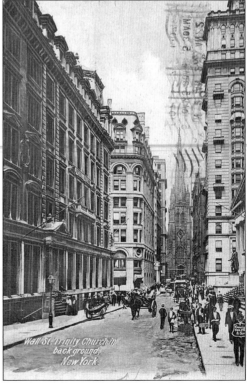

The ten-story Italian Renaissance Revival Wilks Building, designed by Charles W. Clinton, was built between 1889 and 1890. Located on the southwest corner of Wall and Broad Streets, it was owned by Matthew Astor Wilks (died 1926). At age 64, Wilks married Sylvia Green, who was the 37-year-old daughter of Hetty Green, the notorious "Witch of Wall Street." The building was taken down for the 1923 addition of the adjoining New York Stock Exchange.

Built in 1914 to replace the Drexel Building (opposite), the J.P. Morgan & Company Building, was located at 23 Wall Street on its southeast corner with Broad Street. Designed by Trowbridge & Livingston, the white marble structure was seen from its beginnings as a symbol of wealth, power, and prestige, as Morgan chose to build a lower structure when zoning regulations would have permitted a much higher one. The explosion of a bomb at midday on September 16, 1920 was one of the region's worst-ever acts of terrorism, killing 30 and wounding hundreds. Scars in the stone from the blast can still be seen. A new headquarters for the New York Stock Exchange has been proposed for the block.

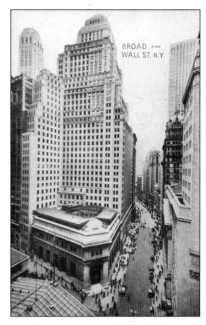

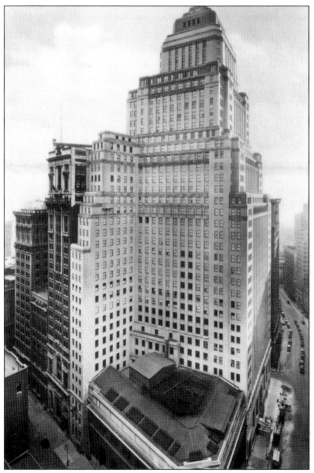

The Equitable Trust Company Building (a unit of Chase Bank) fronts Broad Street at No. 15, but also has entrances from Exchange Place, on the south, and on Wall Street. Also designed by Trowbridge & Livingston, the 43-story, 540-foot-high building containing a reported 750,000 rentable square feet was erected on the site of the 12-story Mills Building of 1882 and appears little changed today. The Trust Company of America Building at No. 37 (page 42) is seen here in its street context on the south side of Wall Street. The corner building is the 18-story Atlantic Mutual's, designed by Clinton & Russell, built in 1901 and replaced in 1959 by the glass and steel structure now on the site. The postcard is a *c.* 1930s Underhill photograph.

31

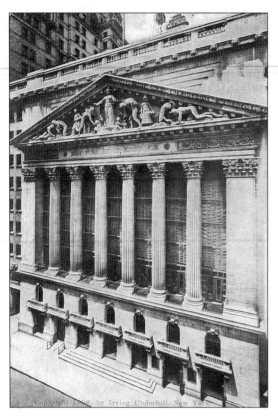

New York City had an active securities market by 1790. The New York Stock Exchange, the principal securities market in America, was organized on March 8, 1817 and occupied a series of rented quarters until it moved into its first owned building at 10–12 Broad Street on December 9, 1865. That significant decade was also marked by an increase in securities trading, competition with other exchanges, consolidation with a principal rival, the Open Board of Stock Brokers in 1869, and the making of New York Stock Exchange memberships salable in 1868. The Exchange relocated to the Produce Exchange on April 30, 1901, while this Neo-Classical building designed by George B. Post was under construction. The new building, which incorporated the 1865 space, reopened on April 23, 1903.

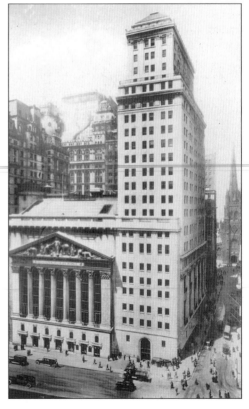

The New York Stock Exchange expanded in 1923, building a 26-story addition, designed by Trowbridge & Livingston, on the southwest corner of Wall and Broad Streets at the location of the former Wilks Building. The north elevation of the Commercial Cable Building is visible at left, while Trinity Church is in the right background. The dome of the Manhattan Life Insurance Company is left of the new building, in front of Adams Express (page 25), and on the west side of Broadway. A new home for the New York Stock Exchange is under consideration as this book goes to press, the block to its east having been proposed. The postcard is of the photographic variety, issued by the New York Stock Exchange for promotional purposes.

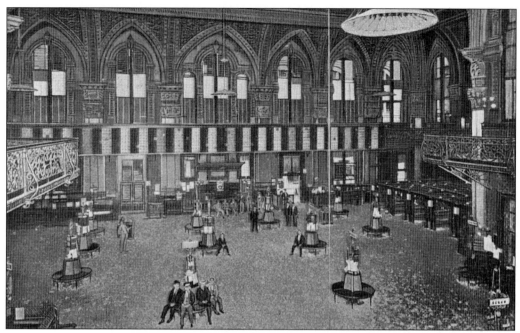

This postcard postdates the New York Stock Exchange's April 1901 closing to construct the building at opposite, but the image is a late 1890s view of the former trading floor. The round benches were trading posts, the signs denoting the specialty of each. The balconies appear to be visitors' galleries. "Sugar," discernible on the sign at lower right, suggests commodities were also traded. Use of the postcard after the new exchange opened is a reminder that dating postcards is an art, not a science.

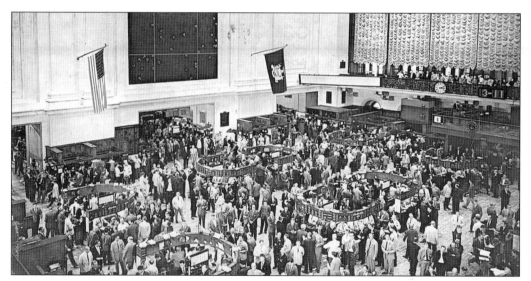

The trading floor of the 1903 building measured 100 by 183 feet, with a height of 79 feet. Much of it is captured in this *c.* late-1950s photograph taken near the 3:30 closing time (3:10 per the clock), when 599 men were visible on the floor. (Do not try to count as this chrome postcard slightly crops the original.) The New York Stock Exchange has long cultivated the public, with this postcard distributed to those visiting their gallery.

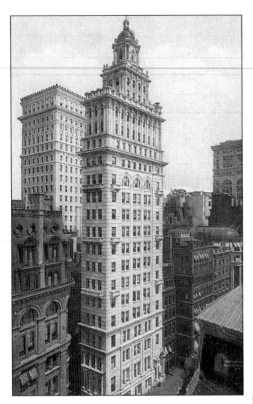

The 19-story Gillender Building, designed by Berg & Clark, stood on the northwest corner of Wall and Nassau Streets from 1897 to 1910 on a site that measured only 25 feet by 73 feet. Earlier, Manhattan Trust had a seven-story building on the site; the origins are obscure. Note that even though it towered over its immediate neighbors, the American Surety Building (page 57) in the background was the area's most imposing structure when it was completed in 1896.

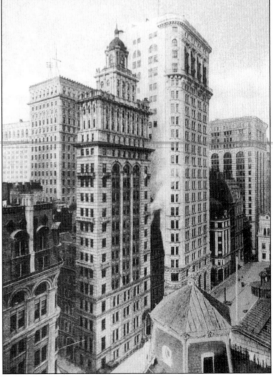

The Hanover National Bank (page 36) towers over the Gillender Building. This c. 1906 postcard looks north, showing a partial view of the old Equitable Building on the Pine to Cedar block and the southeast corner of the National Bank of Commerce beyond it.

The new Bankers Trust Building (see bottom) abuts the Hanover National Bank. Their Nassau Street juncture can now be seen as the 1932 expansion line of the former. The American Surety Building is obscured by the new structure, while the Singer tower almost appears to be atop the Hanover Building. The construction site barely discernible in the right background is for the Guaranty Trust Building on the southeast corner of Broadway and Liberty Street. Note at left the 30- by 40-foot "bandbox" at 1 Wall Street (see pages 56 and 103) and how the Trinity spire appears to be one of the former's roof finials. The 1912 photographic postcard by G.P Hall & Son appears to predate the Equitable fire of January 11 that year, as that building is visible at right.

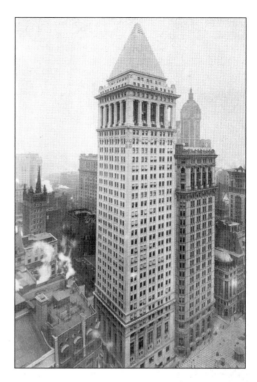

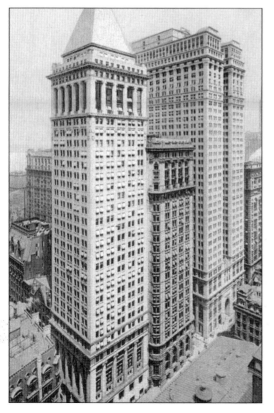

Bankers Trust erected this 540-foot headquarters on the site of the Gillender Building on land that cost a record $825 per square foot. The building was completed in 1912, the same year Manhattan Trust was merged into Bankers Trust. Trowbridge & Livingston designed the 39-story building, which included a seven-story, stepped-pyramid roof set atop the classic style structure's Ionic capital that was inspired by the Greek Mausoleum at Halicarnassus. The position of the camera distorts relative height, but the Hanover Building was then dwarfed by its neighbors, including the huge Equitable Building completed in 1916. The Astor Building is adjacent on Wall Street. It would be demolished for a major expansion of Bankers Trust, seen on the bottom of the next page.

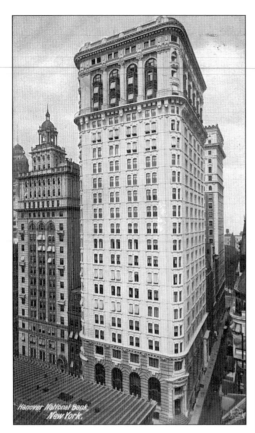

Hanover National Bank.
New York.

Organized in 1851, the Hanover National Bank built this 21-story headquarters on the southwest corner of Nassau and Pine Streets, c. 1900. It replaced both its six-story structure on the same site (barely discernible next to the dome pictured on the top of page 34) and the building adjacent on the south. The lot is extended east over the irregular course of the street. Note there is a narrow building between the Hanover and Gillender Buildings. The mere display of the postcard caused a claustrophobic reaction in one viewer before publication.

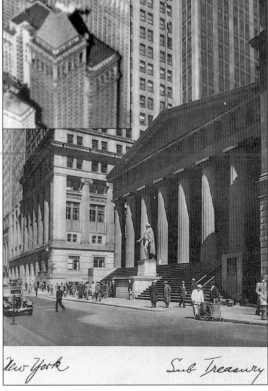

New York Sub Treasury

A 1930s postcard of Federal Hall provides a glimpse at top right of the Bankers Trust L-shaped addition. The addition was designed by Shreve, Lamb & Harmon and was built in 1921 and 1922. It covered the site of the Hanover and Astor Buildings. The difficult-to-photograph Bankers Trust can be best appreciated from the air or a higher building. The inset gives an idea of the structure's shape.

Designed by Charles W. Clinton and completed in 1889, this ten-story Romanesque-style building for the Bank of America was the bank's third on the site at the northwest corner with William Street. The first Bank of America was built in 1812. The 1835 building is seen on the historic print on page 28. The adjacent Merchants National Bank, designed by W. Wheeler Smith and built between 1883 and 1885, was clad in granite of different tints. The shading difference is particularly noticeable on the five-story addition, dating *c.* 1900. The corner is now filled by 44 Wall Street. The Bank of Manhattan Building was constructed on the Merchants site.

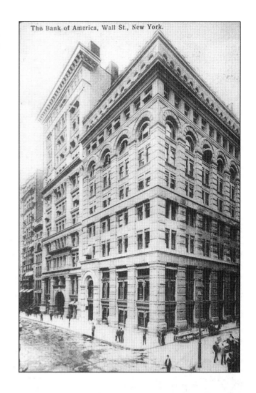

The Bank of America, Wall St., New York.

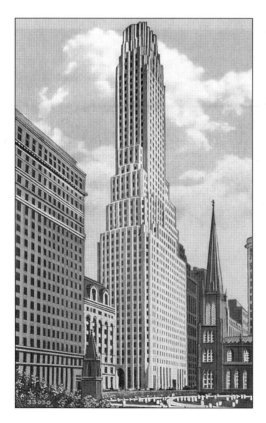

The Irving Trust Company Building was designed by Ralph Walker of Voorhees, Gmelin & Walker. It was erected between 1928 and 1931 at 1 Wall Street on the southeast corner of Broadway. It replaced the 30- by 40-foot "bandbox," the facetious name of the short-lived prior 1 Wall Street, pictured in a panoramic view on page 103. The 52-story, 654-foot-high, limestone-clad building is one of the financial district's most distinctive office towers, richly finished in Art Deco motifs and a dramatic interpretation of the 1916 zoning requirements. The protection of its substantial vaults, 72 feet down in bedrock, included a 6-foot-thick concrete wall, interior metal walls, and a layer of solidified chemicals. The Reception Hall was one of New York's most stunning office interiors. The bank was named for Washington Irving, who had lived on the grounds. A 1965 addition sympathetic to the original was affixed on the south at the site of the Knickerbocker Trust Company. The illustration is a crude white-border postcard, perhaps made from a rendering. Its utility is redeemed as an example of just how bad postcard production sank during that era.

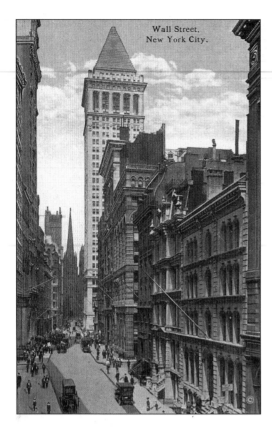

Wall Street west was infrequently photographed east of William Street, but this 1912 Irving Underhill image offers a view of three buildings. The Bank of New York on the corner (opposite the Bank of America), was designed by Vaux & Withers and built between 1856 and 1858, with the mansard added in 1879 by Vaux & Radford. Adjacent is the Royal Insurance Building (also with a mansard roof) and the Romanesque-style New York Life & Trust Company. These two buildings date from the *c.* 1880 period.

The financial district is legendary for the size and enthusiasm of its ticker-tape parades, a tradition still carried out in the canyon of Broadway. Wall Street also has a reputation for knowing how to throw a party. At times, crowds massed in Broad Street during the 19th century in times of financial scare, but one of the street's greatest celebrations was at the end of WWI. The false armistice of November 7, 1911 produced a demonstration, but the actual armistice four days later produced this massive celebration. The dot-studded cloth at front appears to be a service flag, perhaps carried as a banner on which a firm placed a star for each employee in uniform. (Courtesy of Joan Kay.)

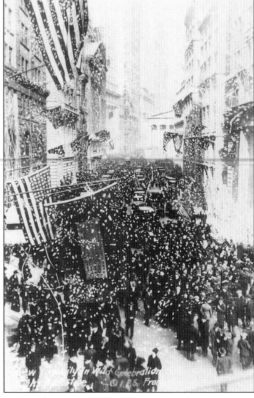

The Bank of Manhattan Building was the financial district's entrant in the great skyscraper race. The 40 Wall Street parcel was assembled in secrecy, but the syndicate of owners announced their plan to build the tallest building in the world. Their 70-story, 927-foot-high building, designed by H. Craig Severance with Yasuo Matsui, would top the Woolworth Building by over 100 feet. At 845,000 square feet, it was expected to yield a substantial return. Completed in 1930, Starrett Brothers erected the structure in record time—one year; it was expected to take two. Chrysler, also aiming for the height title with their Forty-second Street office, appeared to be falling short. However, they trumped the Bank of Manhattan interests by assembling a tower inside the incomplete building, raising it through the roof to reach a height of 1,046 feet. Loss of pride was secondary to the loss of tenants accompanying the Great Depression. The recently renovated office has been owned by the Trump Organization since 1995. The tower in the background is the Bank of America Building on the northeast corner of William Street; it was designed by Trowbridge & Livingston.

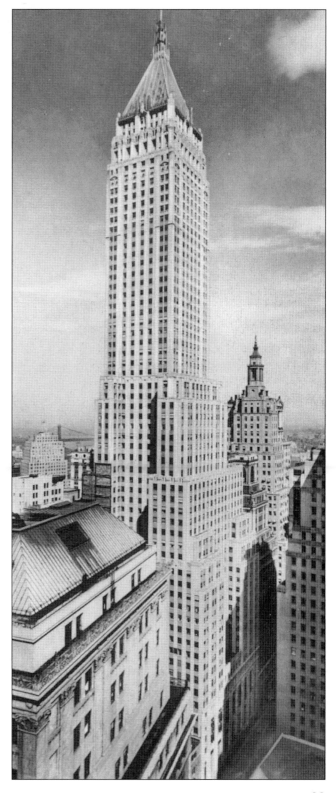

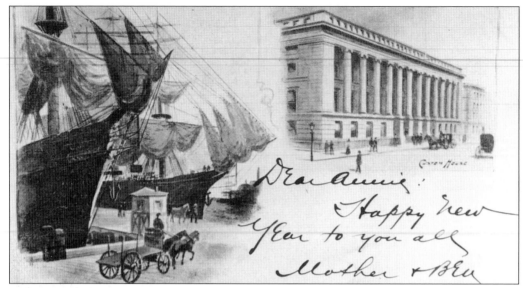

The Merchants Exchange, hailed as the costliest and most pretentious building of its kind in the United States, opened November 17, 1841. It stood on the southeast corner of William Street, replacing a structure destroyed in the 1835 conflagration. The Greek Revival edifice, designed by Boston's Isaiah Rogers, was built of Quincy granite with each of the massive Ionic columns cut from a single piece. A large dome topped the center of the building. The federal government took over the building in 1862 for use as a custom house. Postmarked 1900, the oldest postcard in the book charmingly links the building with its function. (Courtesy of Joan Kay.)

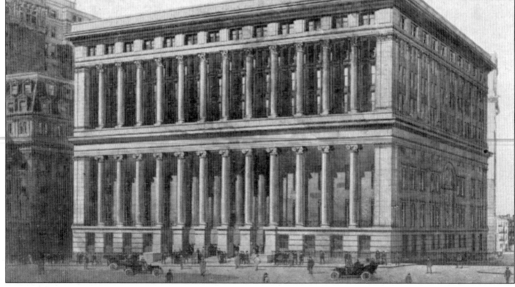

Anticipating completion of the Bowling Green Custom House (page 22), the federal government sold this one to National City Bank in 1899, but did not vacate it for eight years. Charles Follen McKim, partner-in-charge at McKim, Mead & White, designed a five-story addition harmonious to the original. Nearly a century after the 1908 completion of the project, the building appears as one unit. However, the sections are readily distinguishable by the use of Corinthian capitals in the addition that was made from the same Quincy granite.

Charles Follen McKim also designed a classical interior, framing the banking room with 30-foot columns under a 72-foot-high dome. This image is a *c.* 1930s Albertype of executive offices. First National City Bank retained the building as its headquarters until moving to 399 Park Avenue in 1961. The bank continued a branch here after its move, selling 55 Wall Street in 1987.

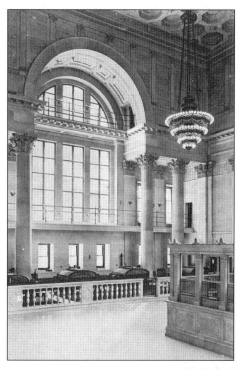

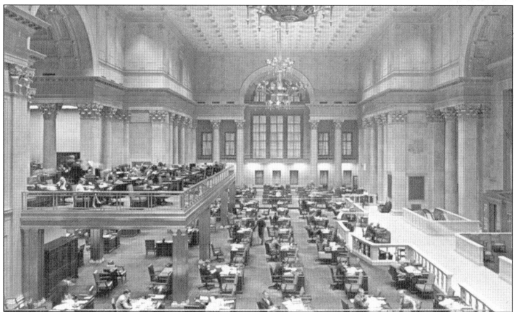

After other re-use plans, the former Merchants Exchange opened as the luxurious hotel, the Wall Street Regent, in December 1999. The former banking room is one of New York's great interiors, perhaps rivaled only by the main concourse at Grand Central Terminal. The 13,000-square-foot hall, which had earlier been adapted for receptions, concerts, and other events, will become a grand ballroom. The hotel occupancy includes a fitness center, restaurant, lounge, and business center.

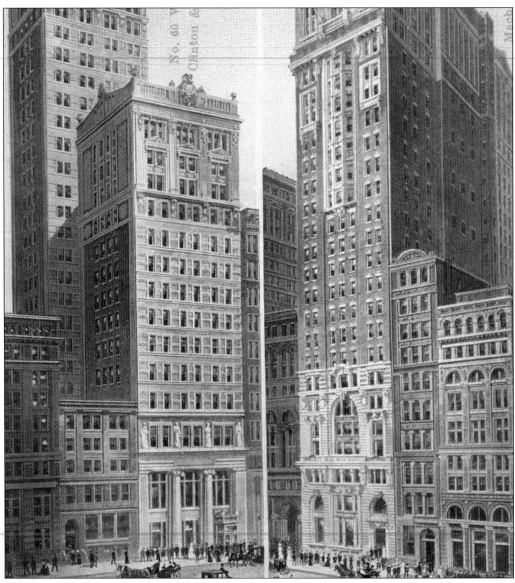

Sixty Wall Street, designed by Clinton & Russell and built by the International Banking Corporation, was completed in 1905. *New York: the Wonder City* claimed it was 346 feet and 27 stories high, but the back of this postcard denoted a height of 362 feet, while the March 12, 1905 *New York Times* indicated it had 26 stories. The lower end fronted on Wall Street, while the rear tower ran through to Pine Street. This example of the difficulty of determining building height will not readily be resolved, as this one was demolished in the 1970s. Its location is part of the site of the present 60 Wall Street. Both this postcard and *Wonder City* suggest the rear tower was part of a Wall Street locale, a precedent for the celebrated 60 Wall Tower, opposite. However, this postcard, seeking to spread location distinction, proclaimed that the 327-foot-tall Trust Company of America Building (right) designed by Francis H. Kimball, was the tallest building "in" Wall Street when completed in 1907. While now dwarfed by several neighbors, this building at 37 Wall Street is the oldest office building on the street. Its future, however, is questionable, as the block has been proposed as a new home for the New York Stock Exchange.

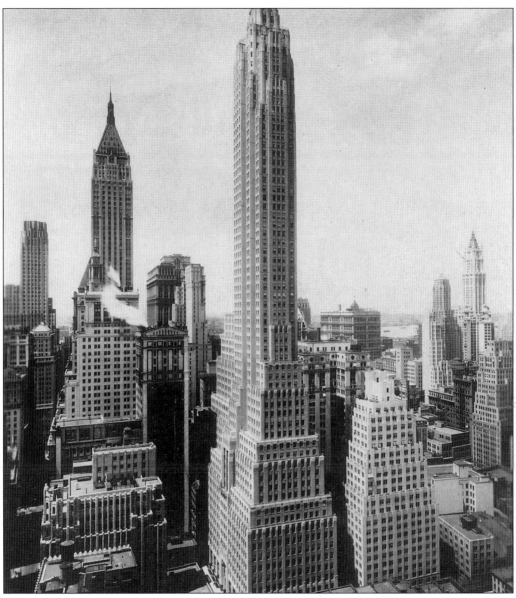

The Cities Service Building (now the American International Group) at 67 stories and 952 feet was the tallest building downtown until the completion of the World Trade Center. The Art Deco masterpiece, with a particularly striking lobby, was designed by Clinton & Russell with Holton & George. It was completed in 1932 and located on the west side of Pearl Street on the block running from Pine Street to Cedar Street. Although its address is 70 Pine Street, the building was long known as 60 Wall Tower, an "address inflation" the owners justified through its connection by an aerial bridge to the former 60 Wall Street. The new building was the first to employ double-deck elevators, an innovation to help justify this size building on a small plot. The former A.I.G. headquarters, at right on the southwest corner of Maiden Lane and Pearl Street, was bought by Cadwalader, Wickersham & Taft in the mid-1980s in the first instance of a large law firm acquiring a major building in New York. The firm renovated it extensively. The tall building to its left is 40 Wall Street (page 39), while at far left is 1 Wall Street (page 37).

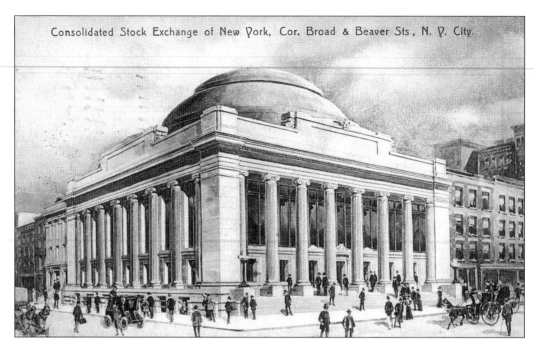

Consolidated Stock Exchange of New York, Cor. Broad & Beaver Sts., N. Y. City.

The Consolidated Stock Exchange was formed by the 1885 merger of the Mining Stock Exchange (founded in 1875) and five others. After nearly 20 years at Broadway and Exchange Place, it moved to the southeast corner of Broad (facing right) and Beaver Streets on August 26, 1907. The Neo-Classical building, designed by Clinton & Russell, had a 95- by 82-foot trading room with 12 trading posts for railroad, mining, and industrial stocks and a wheat pit. Ironically, the design recalled the old Custom House (page 40) at the time that building's expansion was obscuring its origins. Early-20th-century real estate values are reflected by the erection of a $300,000 building on a site then worth $870,000. The building was demolished for the office tower at bottom. (Courtesy of Moe Cuocci.)

The first section of the 33-story, 456-foot-high International Telephone and Telegraph Building, designed by Louis S. Weeks and built by the A.E. Lefcourt Company, was finished c. 1928 at the southeast corner of Broad and Beaver Streets. The Cotton Exchange Building on Hanover Square is visible in the left background. The size of the former was nearly doubled about two years later, filling the southern end of the block visible in this late 1920s white border postcard; the sections' separation is still visible on the Broad Street facade. The building was a communications center for American submarines in the Atlantic during WWII, but has had a checkered existence following ITT's departure. It now appears to be finding a promising future as a telecommunications hub.

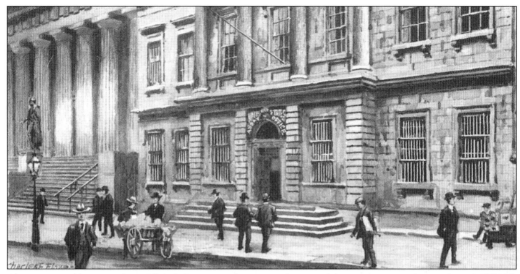

The New York Branch Bank of the United States, designed by Martin E. Thompson and built adjacent to the Custom House between 1822 and 1823, was the oldest Wall Street building until well into the 20th century. Following occupancy by two other banks after the Bank of the United States failed, the building was acquired by the federal government in 1853 and occupied by the Assay office for the assaying, parting, and refining of gold and silver. The metals were received in various forms and, following processing, were turned out in the form of bars bearing a government stamp reflecting weight and purity.

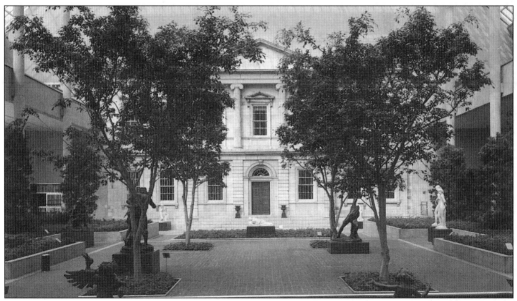

The Assay office was demolished in 1915 and replaced. The American Wing of the Metropolitan Museum of Art, established to install outstanding rooms representative of various historic periods and decorative styles, was extended from the west, or rear, of the Fifth Avenue building. For many years, the facade of the Branch Bank of the United States, a 1924 gift of Robert deForest, was on the building's exterior, but the space was enclosed during museum expansion. It is pictured here *c.* 1980, facing a sculpture court.

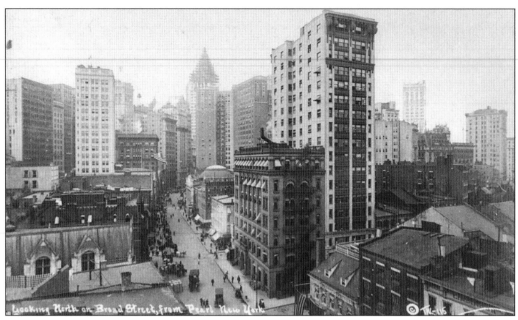

Broad Street is viewed looking north from Pearl Street on this *c.* 1912 photographic postcard, which shows the top of Fraunces Tavern (the structure with the balustrade) in the foreground at the southeast corner of Pearl Street. The image is dated by the background, where the Bankers Trust Building (the pyramidal roof) is seen nearing completion. Note the dome of the Consolidated Stock Exchange (page 44) on a stem of Broad Street that was later filled with office buildings (primarily skyscrapers). A new one at 85 Broad Street now fills the block on the northeast corner of Pearl Street. (Courtesy of Joan Kay.)

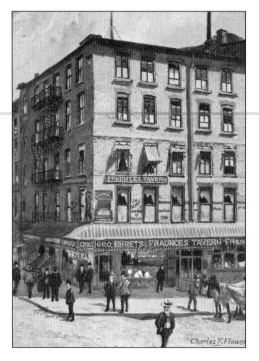

Fraunces Tavern was built *c.* 1719 on early landfill as a private residence for Etienne Delancey. In 1763, Samuel Fraunces bought the tavern at 54 Pearl Street and opened the Queens Head Tavern, which also served as a public meeting place. The tavern took its name in the revolutionary period. The building had been altered and repaired following fire when its earliest claimed image, published in the 1854 *Valentine's Manual*, showed it with a gabled roof from the side. This image from Tuck's "Old Landmarks of New York" Oilette postcard series is faithful to late-19th-century photographs, but no image from the 18th century is known. The building was acquired by the Sons of the American Revolution in 1904, who hired architect William H. Mersereau to restore the building to its colonial-era appearance.

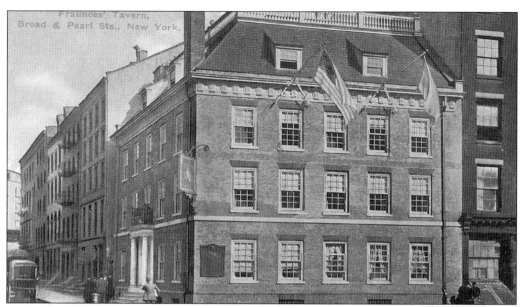

Mersereau claimed his remodeling of Fraunces Tavern was faithful to the original, but the design was controversial in his time. There was no argument over removing the upper stories, which were known to have been added during the building's 19th-century commercial use, but adding the hipped roof was questioned. He used the Phillipse Manor House in Yonkers as a style guide and claimed to follow the roof line of the original, as found during construction, traced on the bricks of an adjoining building. Lack of replication of the original notwithstanding, the building is regarded as an important example of Colonial Revival interpretation and was designated a city landmark in 1965. The surrounding block was designated a landmark district in 1978.

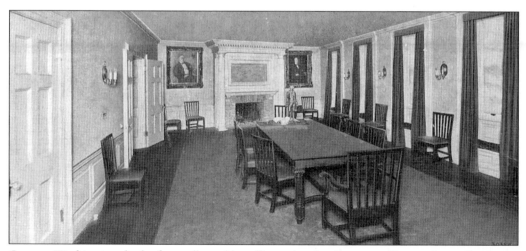

George Washington bade farewell to his officers in the Fraunces Tavern Long Room on December 4, 1783, nine days following the British evacuation of New York after the September 3, 1783 Treaty of Paris ended the war. Fraunces Tavern became a revolutionary shrine after the Sons of the American Revolution opened a museum in 1907 dedicated to 18th-century life and the Revolution; the Sons of the American Revolution acquired a permanent collection and sponsored temporary exhibitions. The Fraunces Tavern restaurant that had been open here for many years announced its closing in January 2000.

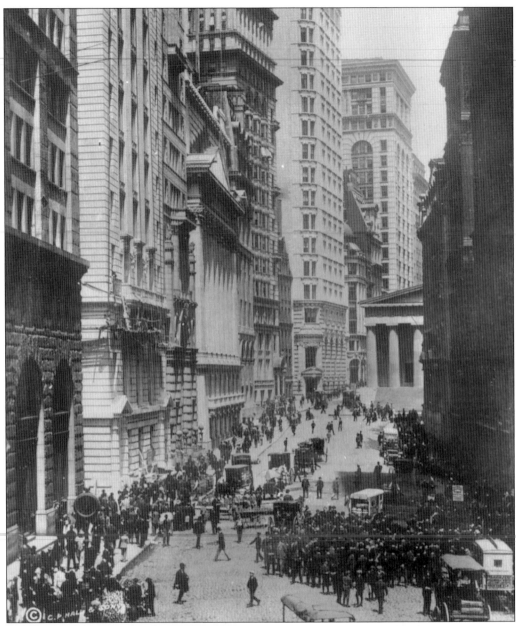

Curb brokers fill the foreground of this c. 1910 photographic postcard looking north on Broad Street. New York had a long tradition of securities brokers meeting in the street to transact business. In the mid-19th century, the curb broker (their widely recognized name) were often of an ilk unable to meet the financial requirements of the established New York Stock Exchange. They tended to trade in less well-established securities, a quality that did not impair business as curb volume at times exceeded the New York Stock Exchange's. The business became better organized, establishing the New York Curb Market in 1911, moving indoors in 1921, and renaming itself the American Stock Exchange in 1953. The office on the north side of the Exchange Place corner at left is the Blair Building is a Beaux-Arts skyscraper designed by Carrere & Hastings; the Johnston Building is at far left.

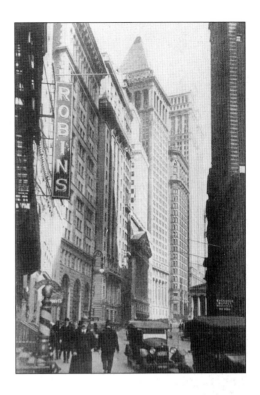

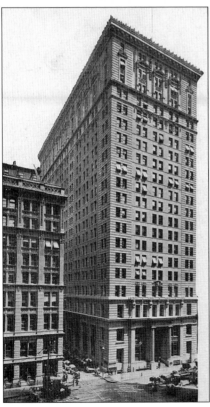

The Bankers Trust Building, completed in 1912 with the pyramidal roof that became a trademark, is a key dating aid for Broad Street photographs. The image at top left predates the *c.* 1922 image to its right. It is unusual as it pictures Bankers Trust together with a part of the 1872 Equitable Building (two blocks north), which was destroyed by fire on January 11, 1912. The dome at upper left is the 1897 Commercial Cable Building, designed by George Edward Harding & Gooch, an unusual project that stacked 21 stories on a lot 45 by 155 feet. The tall building at left in that image is the Johnston Building on the southwest corner of Exchange Place. The Broad Exchange Building, opposite, designed by Clinton & Russell and built in 1901 on the southeast corner with Exchange Place, had sizable dimensions for its time, with a 28,000-square-foot ground area and 340,000 rentable feet in its 20 stories. At left is a glimpse of the Mills Building. Designed by George B. Post and completed in 1882, it was an enormous structure for its day. (Photographs: upper left, courtesy of Stephen Zussman; upper right, courtesy of Charles Kleinman.)

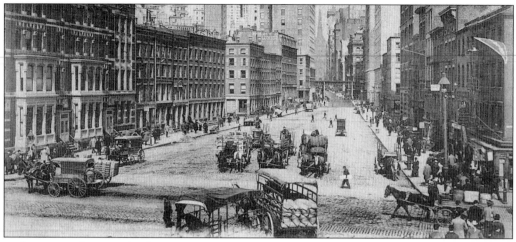

Wall Street widens south of Water Street. The blocks east of the Third Avenue elevated line had not yet been subject to the development active on the street's western stem prior to this *c.* 1900 westward view from South Street. The street then included the five-story No. 108, built in 1794 on Murrays Wharf, which housed Wall Street's last resident, Hugh Harley, who endured into the 1960s, along with his export business. Several skyscrapers line this streetscape today. The 36-story 120 Wall Street, completed in 1930 on the northwest corner, is prominent in the center foreground on the bottom of page 96.

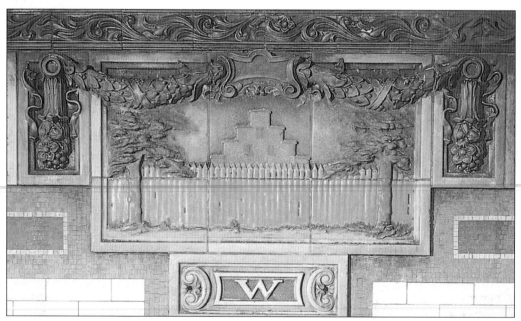

The Interborough Rapid Transit opened New York's first subway line in 1904, decorating several stations with tile bas-reliefs depicting images associated with or describing the stop. A contemporary brochure indicated the treatment was "instructive and decorative, as well as practical, and will have its effect on public taste just the same as anything else that tends to uplift and refine." However, popular lore suggested they were a substitute for station signs or a guide for the illiterate. Grant LaFarge of the IRT's architects, Heins and LaFarge, promoted the Wall Street's depiction of Gov. Peter Stuyvesant's 1653 fence.

50

Four
BROADWAY
NORTH OF WALL STREET

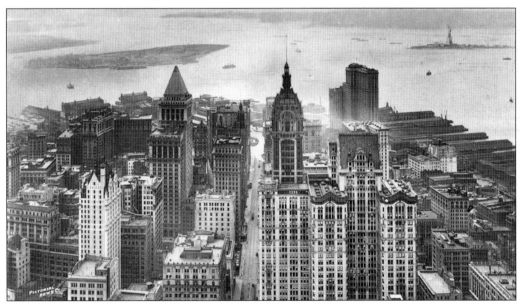

The west side of Broadway looking south *c.* 1914 is obscured by two prominent buildings in the foreground, the City Investing Building and the Singer Building (the one with the tower), both seen on page 62. The foreground of the east side has two buildings not seen elsewhere in this book, the Lawyers Title Insurance and Trust Company, No. 160, on the bottom edge, and the American Exchange National Bank Building, No. 128, above it. Both were designed by Clinton & Russell. The American Surety Building at No. 100 (page 57) is above the latter; it is visible because the 1916 Equitable Building had not yet been built at No. 120. The Liberty Tower (page 78) is at left, while the pyramid is the roof of the Bankers Trust Building (page 35). The Whitehall Building (page 15) is in the right background. The two islands are Governors, at left, and Liberty.

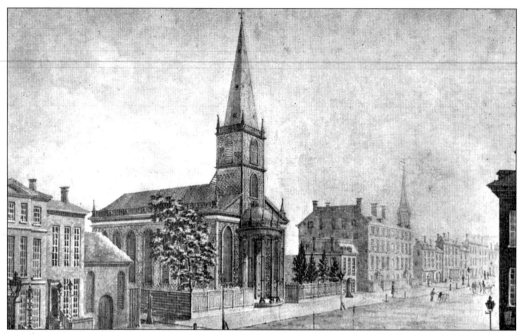

Trinity Church, founded by charter from King William III of England in 1697, built a church the next year on Broadway at the foot of Wall Street; it was destroyed by the Great Fire of 1776. This edifice, begun in 1788 on the same site, was consecrated by Bishop Provoost in 1790 in distinguished company, including President Washington. Seen on a historic print reproduced on this *c.* 1950 monochrome postcard, the building was demolished in 1841 to erect the present church, following the discovery of structural problems.

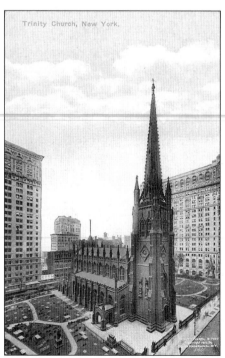

The third Trinity Church edifice was built between 1841 and 1846 as an early commission of ecclesiastic specialist Richard Upjohn, who designed the work to resemble an English country church. It is one of New York's finest Gothic Revival buildings. The Trinity Church is the center of a parish comprising several chapels in various parts of the city, including St. Paul's (pages 64 and 65). Trinity conducts numerous outreach programs to the disadvantaged, an aspect of its ministry dating from its 1705 service to both enslaved and free blacks. The church is 202 feet long, 78 feet wide (exclusive of All Saints' chapel and the Manning Memorial Wing), while the height from the floor to the apex of the roof is 80 feet and 9 inches. This 1912 postcard shows the Ninth Avenue Elevated line on Trinity Place in the background and, at left, a glimpse the 1906 building at 2 Rector Street, pictured before its uppermost stories were added.

Elaborate carved English oak furnishings were installed at the north and south sides of the chancel above the clergy stalls. The pictured north side has been altered by the removal of the stalls for what appears to be an organ console. The organ installed at the time of this *c.* 1910 photographic postcard consisted of the original Henry Erben instrument in the gallery and a separate small choir organ installed in the chancel in 1864. A new Skinner organ in 1923 combined the two instruments. Trinity Church has an ambitious and effective music ministry, its Noonday Concert series richly enhancing downtown's cultural life.

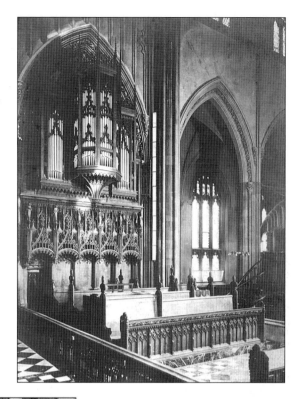

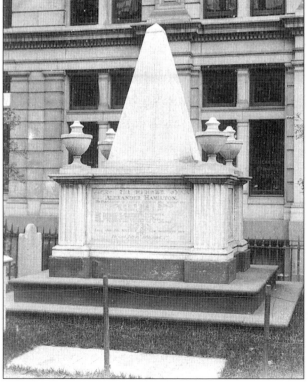

The Trinity Churchyard contains the remains of a number of prominent Americans, including Robert Fulton, Albert Gallatin, and Capt. James Lawrence. It also houses gravestones, reflecting funerary practice and belief of the times of their interments from the 17th through the 19th centuries. The pictured pyramidal monument belongs to Alexander Hamilton, the youngest of the 55 framers of the Constitution and the first secretary of the treasury. He died July 12, 1804, the day after he was struck by Aaron Burr's bullet in a duel in Weehawken, New Jersey. The image on this *c.* 1905 Rotograph postcard faces the Rector Street elevation of the Empire Building (page 23). Eliza, Hamilton's widow and daughter of Philip Schuyler, survived her husband by 50 years and is interred with him.

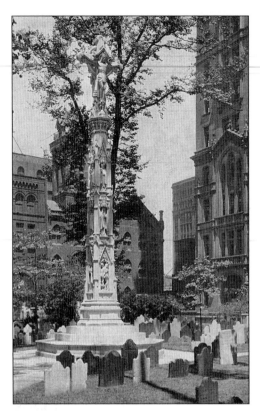

Designed by architect Thomas Nash, the Astor Cross, alternately known as the Churchyard Cross, was erected by Mrs. M. Orme Wilson as a memorial to Caroline Webster Astor, her mother, who was buried at the Trinity Church Cemetery at Broadway and 155th Street. She was the wife of William Astor, grandson of John Jacob Astor. The 39-foot-high cross consists of four blocks of Indiana limestone on which are carved numerous figures. Mary and the crucified Jesus are at top. Facing Broadway and the camera are Judah, Shem, Adam, and Eve. Facing the south and partially visible at left are David, Jacob, and Noah with a model of the ark. Jesse, Isaac, and Enock face west, while Ruth, Abraham, and Seth face north toward the Trinity Building at right.

The image of the Soldiers Monument commemorating unknown soldiers and sailors of the American Revolution who were buried nearby identifies the steel skeleton as the Trinity Building. A second construction project is visible in this 1904 image; notice the crane mounted on a bridge use for the tunnel work of the Broadway IRT subway, built using the "cut and cover" method. The roadway was spanned with temporary planking during the day; tunnel work on this extremely bury thoroughfare was limited to the off hours. The partially visible piping in the lower right corner is a set of gas mains, which were temporarily elevated during construction.

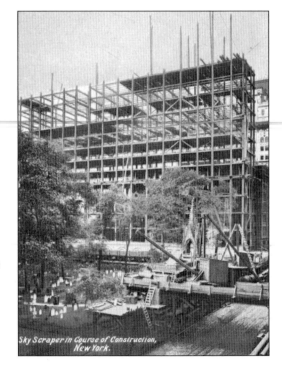

Sky Scraper in Course of Construction, New York.

Organized in 1901 by a number of high-powered New York real estate figures, the U.S. Realty and Construction Company bought the old Trinity Building in 1902. The company also bought a narrow office at 111 Broadway with a long frontage on the north boundary of the Trinity Churchyard, hoping to relocate Thames Street to the south in order to widen their lot. Unable to acquire the necessary land in a timely manner, they built this 21-story, limestone-clad office, designed by Francis H. Kimball. When completed in 1905, it had a plain brick north elevation as an expansion was planned. U.S. Realty acquired the needed property and had Thames Street relocated 28 feet to the north. The company expanded the new Trinity Building, planning a similar structure north of Thames Street. Compare the width of the building in this *c.* 1905 image with the building at left below.

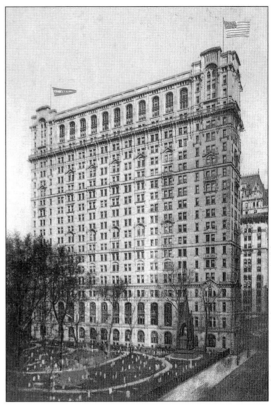

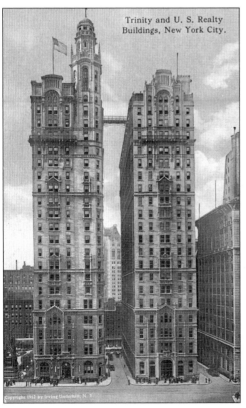

Trinity and U. S. Realty Buildings, New York City.

Copyright 1912 by Irving Underhill, N. Y.

U.S. Realty named the building completed in 1907 at No. 115 for itself. Kimball's Neo-Gothic designs were novel for office structures at the time. The nearby subsoil required the considerable engineering feat of resting each building on 70 pneumatic caissons, sunk about 75 feet. The buildings are at times called the "twins," a reasonable surmise by the casual passer-by. However, the Trinity Building's expansion is clearly visible, while the U.S. Realty Building employs the same elements in a symmetrical design. Each is built on a narrow 67-foot lot. A tower was actually added to the former to avoid an identical image. Narrow Thames Street is between them, creating the type of canyon that would be addressed by the 1916 zoning law. The facades are unchanged today. The two buildings completed a major renovation in the late 1990s. A glimpse of the West Street Building (page 116) is in the background.

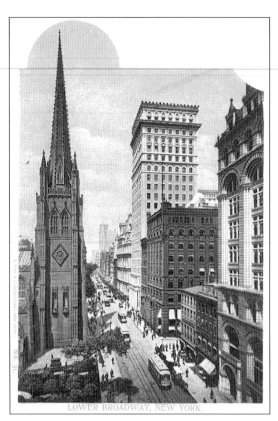

LOWER BROADWAY, NEW YORK.

The corner of Broadway and Wall Street, regarded in the early years of the 20th century as New York's most valuable piece of real estate, was underutilized on its south side when occupied by the Connecticut Mutual Life Insurance Building, *c.* 1903. A partial view (right) of George B. Post's design for the Union Trust Company of New York Building, completed in 1890, shows its resemblance to the north facade of his New York Times Building (page 121). The three buildings south of the corner would be replaced by the Irving Trust headquarters (page 37).

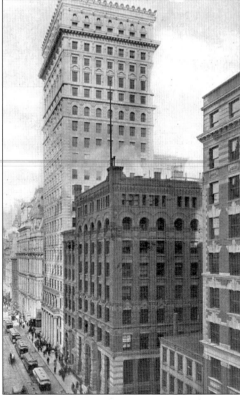

A similar *c.* 1908 view closer to the corner shows, at right, part of an 11-story building that replaced the one off the corner, at top. The adjacent building was replaced by a short-lived 18-story office (page 35, top) built on a 30- by 40-foot plot, the dimensions of a sizable living room. The project was aided by use of small elevators. The United Bank Building, designed by Boston's Peabody & Stearns, was completed in 1881 on the north side of Wall Street. It would remain until replaced in 1933 by the 21-story First National Bank Building now on the site.

Completed in 1896, architect Bruce Price's American Surety Building at 100 Broadway set a new standard for skyscraper aesthetics. The 21-story, 312-foot Maine granite-clad building, erected on a lot of only 85 square feet, was not only a graceful shaft of Beaux-Arts influence design, but also presented a finished facade on each of its four elevations, contrary to the frequent practice of leaving the rear and/or sides of buildings bare. The postcard, if not published by the firm, was adapted by American Surety for promotional purposes, having a three-word slogan printed in orange on the message side: "Surety on Bonds." The corporation was founded in 1884 to specialize in the providing of suretyship, a financial guaranty then generally secured by personal guaranty. The building was significantly altered in 1921 by a 40-foot expansion on all sides, which maintained its square shape and greatly expanded its space, but at the expense of its gracefulness. Note the female figures sculpted by J. Massey Rhind over the Ionic columns on the Broadway entrance.

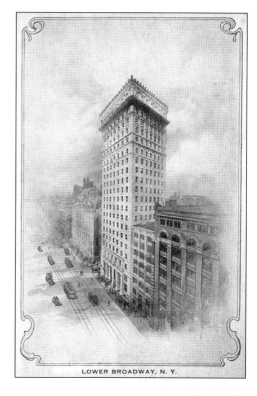

LOWER BROADWAY, N. Y.

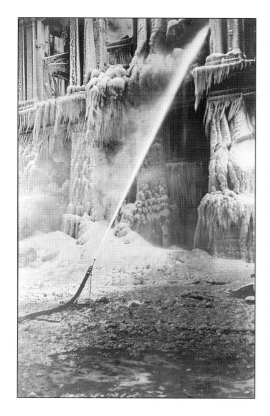

A partial view of the Equitable Building completed in 1870 at 120 Broadway is shown in the three preceding pictures. The structure was designed by Arthur Gilman and Edward H. Kendall, winners of a competition, with George B. Post, a consulting architect whose work embraced improving the structural support system and arranging interior fire-resistant partitions. Equitable was concerned about fire. The Equitable, the first office building in New York to have a passenger elevator, was the city's first modern office building, a distinction based on several criteria, including size, height, plan, and technological features. The building was so much a company symbol, that Equitable founder Henry Baldwin Hyde wrote the architects in 1893 claiming that "without the Equitable Building as a fulcrum from which to move the insurance world, the unparalleled results attained by the Equitable Life Assurance Society of the United States could never have been accomplished." The building was destroyed in a spectacular fire on January 11, 1912. The photographic postcard served as a news photograph of the times.

57

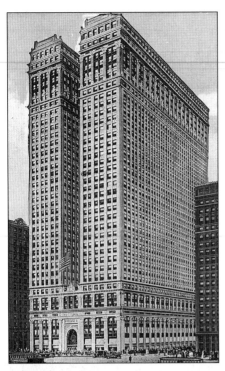

The Equitable, although having announced plans in 1909 to build a 909-foot tower, completed this structure in 1916 on the site of the destroyed building, the block bounded by Broadway, Nassau, Pine, and Cedar Streets. It attained a height of "only" 542 feet, with about 38 stories (the count varies). It was the fifth tallest building in New York, but at 1.2 million square feet, it was the world's largest in terms of area. The new building, designed by Chicago architect Ernest R. Graham in an H shape, was reviled for its bulk and the shadows it cast. The building would become a symbol of business greed. It was popularly regarded as the reason for the passage of the 1916 zoning law, which limited building size, although that law had been years in the planning and the dates were merely coincidental. Its provisions would have restricted the Equitable Building to floor space that was 12 times its plot size, in lieu of the factor of 30 times the plot size, as it was built. The postcard is a crude early white border made from a rendering.

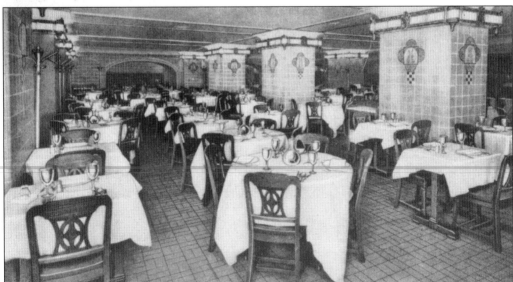

The Café Savarin, buried in the basement of the bulky Equitable Building, lived up to the reputation of its namesake gourmet, having been esteemed as one of finest downtown restaurants. A holdover from the old Equitable Building, a 1925 guide claims it was also "the last word in the cleanliness of modern tiling, the walls and ceiling being finished, in this instance, in a dull blue which, with artificial lighting, creates a pleasant impression of daylight in the cavernous grottos." Designed by John S. Petit, the color came from a blue, six-inch tile that lined its three dining rooms, which could seat 1,000; this is the men's café. Other Savarins were opened uptown, including Forty-second Street, Penn Station, and the Waldorf-Astoria Hotel.

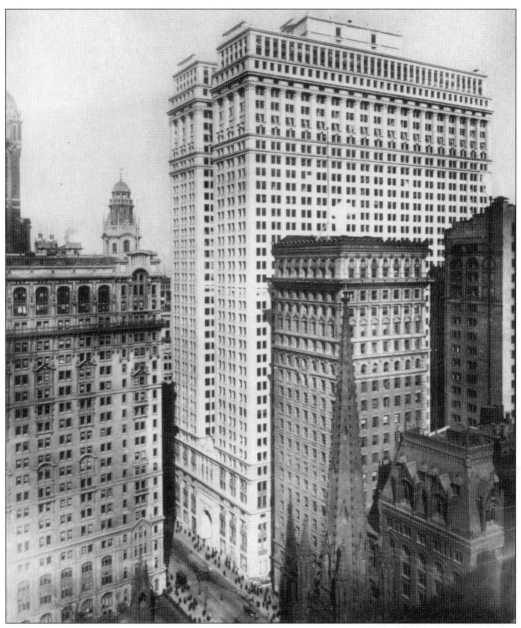

This *c.* 1920 photographic postcard reflects the ongoing redefinition of "big" in New York building. Few remember that Trinity Church had dominated the downtown skyline since 1846. The American Surety Building looked over everything in its surroundings in 1896, but the 1916 Equitable Building placed in their midst a new standard for bulk that makes an impact even today. The latter received an extensive restoration in the 1980s and was designated a National Historic Landmark in 1996. Parts of Trinity Church's exterior were black from decades of grime. A cleaning completed in 1991 restored the light hues of its New Jersey brownstone. The American Surety Building had numerous interior and lobby modifications in the 1970s and 1980s. However, its stature was also recognized by a New York City landmark designation in 1997. The Trinity office was extensively refurbished after receiving landmark status in 1988.

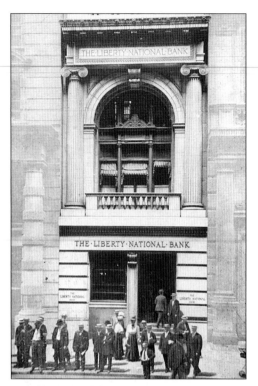

The Liberty National Bank was built in 1903 on the west side of Broadway, near Liberty Street. The latter street is now filled by a park that was made by the transfer of air rights to 1 Liberty Plaza, the location of the former United States Steel Building on the north side of Liberty Street. C.L.W. Eidlitz's designed in the emerging Neo-Classical style that would become a bank standard for three decades. The message side of this postcard was filled with a summary of the bank's financial statement for November 27, 1906, when Frederick B. Schenck was president and deposits totaled $20,550,537.34. (Courtesy of Joan Kay.)

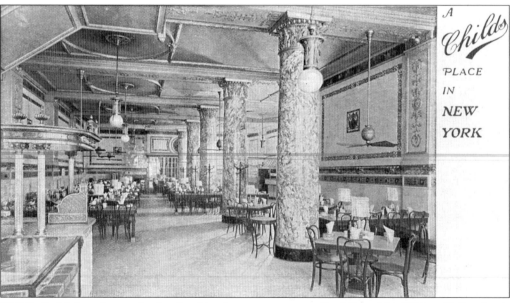

Child's Quick Lunch was the fast food leader a century ago. Established in 1889 at 41 Cortlandt Street by William and Samuel Childs, the chain was based on the principles of quality food and efficient service. Although this postcard is not positively identified, their 130 Broadway location cost $100,000 in c. 1897 dollars. Some things do not change. An 1898 description of the busy establishment described visitors awaiting a vacant chair as people "whose faces show that they are begrudging the diners the time they seem to think the latter are evidently taking from them".

Clinton & Russell designed the 19-story, 234-foot building at 170 Broadway on the southeast corner with Maiden Lane. The George A. Fuller Company constructed it in 1902. The only visible changes are the entrance and storefronts. Maiden Lane was a jewelry center. C.W. Little used this postcard in 1907 to announce their move from nearby Cortlandt Street. (Courtesy of Joan Kay.)

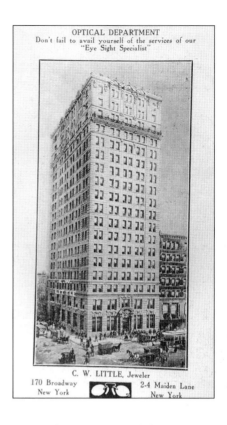

OPTICAL DEPARTMENT
Don't fail to avail yourself of the services of our "Eye Sight Specialist"

C. W. LITTLE, Jeweler
170 Broadway
New York
2-4 Maiden Lane
New York

This 1900 view of Broadway north from Dey Street shows only a partial view of an altered Western Union Building, an important early work of George B. Post, the winner of a design competition. The structure, completed in 1875 at 230 feet, was then the tallest commercial building and about four times the typical height of nearby buildings. In that decade, it provided a high-rise presence on the skyline in addition to the Tribune Building (page 121), the Brooklyn Bridge towers (page 124), and Trinity Church. The building housed Western Union offices, rental space, and water tanks. It also had telegraph operating facilities, including a battery room that powered the system. When it was new, the building had a mansard roof and tower. Although Western Union found the building symbolically useful, using height to imply corporate power, artistic distinction gave way to pragmatism, as the upper story, the mansard roof, and the tower were replaced by the four top floors visible in this Detroit Publishing Company postcard. The Mercantile National Bank, typical of the five-story buildings that once lined old Broadway, is on the opposite corner.

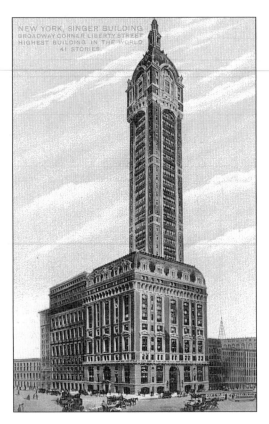

Architect Ernest Flagg had been a vocal opponent of the tendency to build ever-higher and bulkier office structures. Flagg's ten-story headquarters for the Singer Manufacturing Company, built in 1899 at the northwest corner of Broadway and Liberty Street, later provided an opportunity to use height with grace and dignity. The tower, added in 1908, made the 47-story, 612-foot office the world's tallest. It also provided Singer a corporate symbol that it used extensively in promotion, although they only occupied a single floor. A tower observatory could be accessed by the public for a charge of 50¢. However, it was closed after proving popular as a platform for suicides. A richly decorated lobby gave Singer an interior grandeur rarely attained by an office building. Demolition began in August 1967. Once the world's highest building, the Singer is now distinctive as the tallest building ever razed.

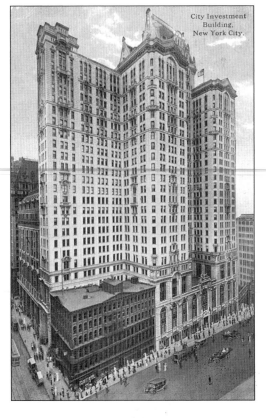

The bulk of the City Investing Building was adjacent to the new, graceful Singer tower and was completed the same year, 1908, at 165 Broadway, its north elevation also fronting Cortlandt Street. Francis H. Kimball designed the 34-story, 480-foot building that was erected for its rental potential. Indeed, its 13 acres of floor space is believed to have been the world's largest office building in terms of area. The structure, spanning the full block to Church Street, had a solid marble lobby running from 30 to 50 feet wide. The Wessels Building stood on the corner. Its air rights were used by the City Investing Building, which was demolished for construction of 1 Liberty Plaza (page 107).

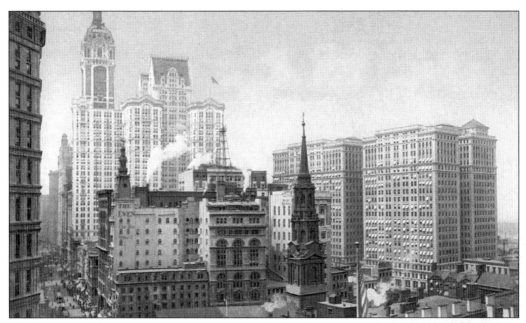

The Singer and City Investing Buildings are in the background, while Hudson Terminal (page 108) is at right. The street in the foreground of this c. 1910 Detroit Publishing postcard of Broadway's west side is the block between Dey and Fulton Streets. Pictured prominently is the Mail and Express Building, built with 25 feet of frontage on Broadway. Its T-shaped plan included three bays facing the church. The 11-story, 211-foot building plus tower was designed by Carrere & Hastings. The block was cleared for construction of the American Telephone & Telegraph Company Building.

The American Telephone & Telegraph Company headquarters at 195 Broadway, designed by William Welles Bosworth, was built in two sections in 1913 and 1916 that were effectively joined so their separate origins are unnoticeable. Eight three-story Ionic colonnades were placed on a tall Doric base. Massive Doric marble columns fill the lobby, creating one of New York's most powerful office interiors. A cupola on the northwest corner was modeled on the mausoleum of Halicarnassus. Barely visible on this 1920s white border postcard is the Evelyn Beatrice Longman sculpture *Genius of Electricity*. The sculpture was moved twice, first in 1981 to AT&T's new headquarters at 550 Madison Avenue (and then renamed *The Spirit of Communication*) and later to Basking Ridge, New Jersey. According to an announcement made in March 2000, efforts were underway to find a New York City home for the sculpture, not a simple task for a four-story colossus. You are getting old if you remember when the nude male figure, popularly called *Golden Boy*, was on the cover of nearly every telephone book.

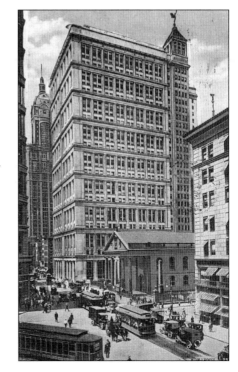

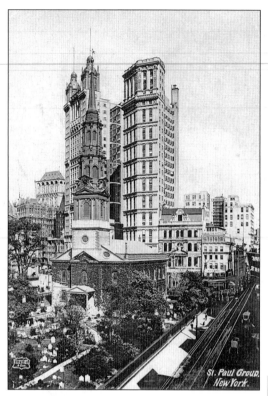

St. Paul Group.
New York.

St. Paul's Chapel was built from 1764 to 1766 according to a design attributed to Thomas McBean and was modeled after James Gibbs' St. Martin-in-the-Fields in London. It is Manhattan's oldest house of worship in continuous use. The Park of Trinity Parish was erected for the convenience of their "uptown" worshippers. The church, also one of New York's finest Georgian buildings, faces its graveyard on the west. The tower, designed by James Crommelin Lawrence, was added in 1794. The five-story building on the east side of Broadway is the National Park Bank, founded in 1856, which moved here in 1868 from Beekman Street and Theater Alley. Knox the Hatter was a longtime occupant of the northeast corner with Fulton Street. Note at left the distinctive roof of the American Tract Society Building (page 122), a feature still best viewed from a distance.

The National Park Bank acquired lots east of the corners on Ann and Fulton Streets in 1893 and expanded the bank to a T-shaped plan. The expanded bank was remodeled with a Neo-Classical design by Donn Barber, c. 1906. Note the statues, the *Races of Man*, by sculptor Karl Bitter over the entrance to the St. Paul Building (page 66). The view east is along the narrow Ann Street, running three blocks to Gold Street, a vestige of old New York that inspired Charles Ives to write a namesake song. In 2000, one can still see a collection of narrow brick buildings there, reminiscent of most of the area a century ago. Ann Street was an early home to the printing industry and, in the 1850s, became a gathering place for sharpers and gamblers. Some of their illicit gaming houses, notably on the pictured block, lasted into the early 20th century.

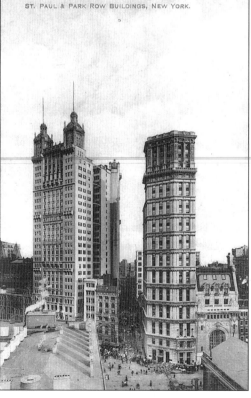

ST. PAUL & PARK ROW BUILDINGS, NEW YORK.

The St. Paul east, or Broadway facade, is the image familiar to most passers-by and is now used as the main entrance. The exterior cladding is native stone, Manhattan mica-schist, with brownstone quoins. An old carved-oak statue of St. Paul stands in a niche in the pediment. Revolutionary War hero Gen. Richard Montgomery was interred under this porch when he died in 1775. A memorial to him by Italian sculptor Jacques Caffieri, erected in 1789, is visible in front of the Palladian window. Note the attractive iron fence that surrounds the property. The postcard is a *c.* 1950 monochrome.

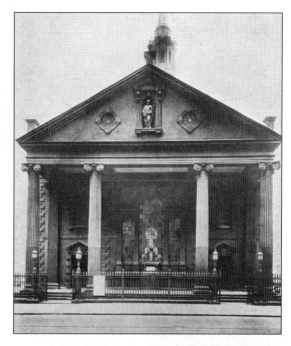

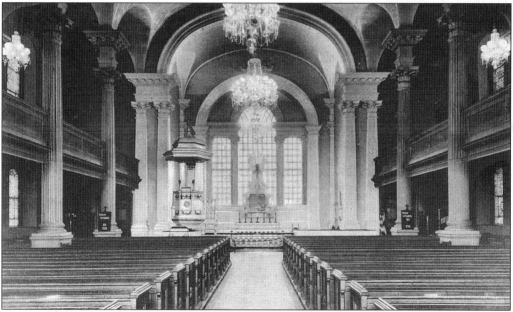

Over the St. Paul altar on the east, or Broadway end, is an ornamental design of *Glory*, depicting Mount Sinai amid clouds and lightning, the Hebrew word for God in a triangle, and two tablets with the Ten Commandments. The altar was designed by Pierre L'Enfant along with other interior finishing, including the altar rail. Decor includes what is believed to be the only emblem of British nobility remaining in New York on the 18th-century pulpit and 14 original Waterford cut-glass chandeliers. The postcard is a *c.* 1930s Albertype by a Brooklyn publisher that maintained the high quality of its product during the dismal eras of postcard production. L'Enfant would later lay out Washington D.C.

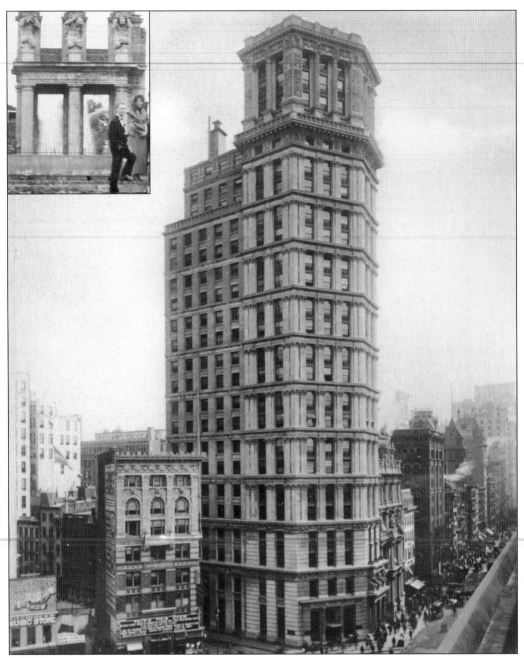

The 25-story St. Paul Building, designed by George B. Post, briefly held the distinction of the world's tallest office at 307 feet when it was completed in 1899 at the southeast corner with Ann Street. Note that two floors are between each of the belt courses, continuous to the top of the building. It replaced the former Tribune Building on a site earlier renowned as the location of P.T. Barnum's museum, which was destroyed in a spectacular fire on July 13, 1865. The north corner was cleared in 1999 the expansion of a music store. The St. Paul Building was demolished in 1959, but the Bitter statues were preserved and installed in a grotto called "the ruins" in Indianapolis, Indiana's Holliday Park (inset).

George Washington worshiped at St. Paul's for two years. He was present at a special service on Inauguration Day, April 30, 1789. St. Paul's has cultivated its historic significance, as Washington's pew in the north aisle is maintained as a tourist attraction. The chapel is also a concert site for Trinity's ambitious music program. At left is 222 Broadway, built in 1960 on the site of the St. Paul Building as the headquarters of Western Electric Company, which then occupied all 21 stories. This view on this early 1960s chrome was taken from the northwest corner of Church and Vesey Streets. Note the patchwork pavement exposing the old cobblestones. Anyone who thinks they are charming never drove over them; walking while wearing women's heels is unthinkable.

John Jacob Astor began to build the Astor House in 1834 on a fashionable residential block on the west side of Broadway after acquiring the land at enormous cost. The Greek Revival-style building with over 300 guest rooms, designed by Isaiah Rogers and completed in 1836, was New York's first great hotel and the beginning of a long Astor ownership of choice hotels. As the neighborhood changed over the decades to an almost completely commercial character, the Astor House endured by catering to the needs of surrounding merchants. Thus, it could make a claim as the financial district's first business hotel. The Astor House, once running the block from Vesey to Barclay Street, was in the way of subway expansion and was demolished in two sections beginning in 1914. The Astor House Building (page 68) and the Transportation Building (page 71) are now on the site.

This *c.* 1920 view from the AT&T Building spans the juncture of Park Row (right background), Vesey Street (left), and Broadway. Designed by Robert D. Kohn and completed in 1906, the Evening Post Building at 20–24 Vesey Street (far left) stands unchanged, with the exception of different storefronts. Designed by Charles Adams Platt and built in 1915, the Astor House Building, an office on the corner, is undergoing an extensive renovation in 2000. Still standing in this view is the northern section of the Astor House. The westernmost of the five-story buildings, No. 18, is virtually unchanged while the others were replaced in 1930 by the New York County Lawyers Association Building. The buildings on Park Row and the Municipal Building (background) are described in chapter seven.

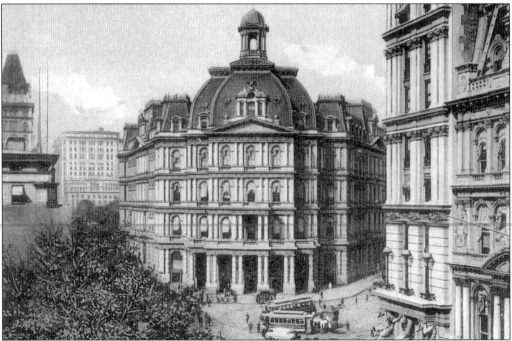

The post office and United States Courthouse built at the southern tip of City Hall Park (on land sold to the federal government for $500,000 in 1867) stemmed from a collaborative design of the five top finishers of a competition. Their work was modified by Alfred B. Mullet, the supervising architect of the U.S. Treasury Department who received credit for the finished design. Ground was broken in August 1869, but work and appropriations progressed slowly; expanding the project after construction began did not help either. The post office was occupied in August 1875, but work on the upper stories was discontinued for a year and the building was not completed until 1878.

Locating a post office in a prominent park today would be understandably impossible. Opposition in the 1860s was vocal, but the choice was forced on an unwilling public. Noted lawyer and diarist George Templeton Strong, writing at the August 9, 1869 groundbreaking, expressed mixed feelings: "Yesterday they broke ground for the new post office at the south end of City Hall Park and today a great wooden enclosure is going up around the site. This will destroy the best-known and most characteristic street view in New York, viz., looking up from Fulton Street and Broadway across the Park to the south front of the old City Hall. 'The Park' will be destroyed, but it has long survived its usefulness, except as a place for blackguard boys to pitch coppers in all day, and for thieves and ruffians to meander through all night."

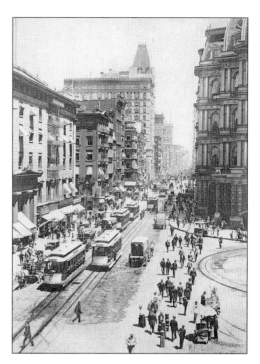

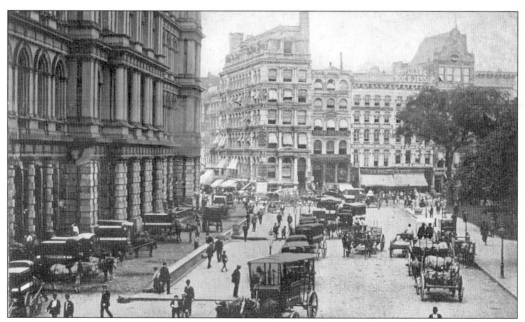

The post office's triangular site included 240 feet on what remained of City Hall Park (right), 340 feet on Broadway (with the background picturing the block from Park Place to Murray Street), 320 feet on Park Row, and 130 feet facing south toward the apex of the triangle. The first story was 29-feet high, while the court rose 60 feet from the second to the fourth floor. The post office became the City Hall Station after the general post office on Eighth Avenue opened in 1913. The building was demolished in 1938.

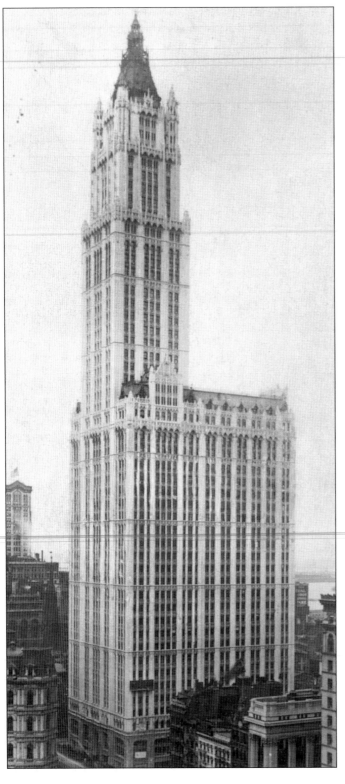

The Woolworth Building, a famed New York icon and symbol of the wealth and power gained by the venerable retailer's nickels and dimes, was completed in 1913, attaining builder Frank W. Woolworth's aspiration to own the tallest building in the world. He could well afford to achieve his goal and paid for it in cash. Architect Cass Gilbert's Neo-Gothic building, with a granite base and terra cotta cladding, rises 792 feet at 233 Broadway, the block between Park Place and Barclay Street. Although widely employed as a corporate symbol, Woolworth then occupied only one floor, renting the remainder of a structure esteemed as the Cathedral of Commerce. Time and changing retail practice passed by this symbol of Americana. Once a predictable presence in any good-size town, Woolworth closed the five & dime stores that once made it a retailing giant, changing its corporate name to the Venator Group and its business to sportswear and athletic shoes (or "sneakers" to old-timers). The company sold the building in 1998.

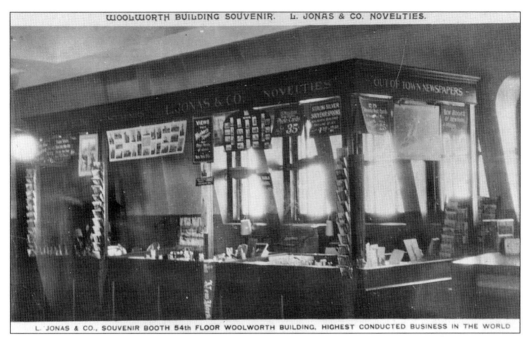

L. JONAS & CO., SOUVENIR BOOTH 54th FLOOR WOOLWORTH BUILDING. HIGHEST CONDUCTED BUSINESS IN THE WORLD

Postcards were obviously a popular item at the Jonas & Company souvenir booth on the 54th floor, where for 50¢ one could transfer from an express elevator to a shuttle elevator to go to the outdoor octagonal observation deck. (The deck was closed long ago.) The lobby is richly decorated with mosaics, murals, a stained glass skylight, bronze doors, and company figures (and the architect) interpreted as gargoyles. It is one of New York's grandest interiors; it still attracts tourists and is worth a trip.

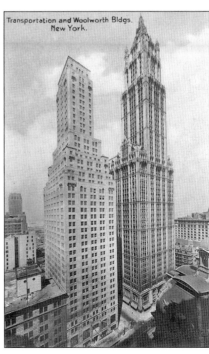

Transportation and Woolworth Bldgs. New York.

Designed by York & Sawyer, the Transportation Building, rising 44 stories and 542 feet at 225 Broadway, was completed in 1928. York & Sawyer's Federal Reserve (page 79) design set a new standard for banks, but their Broadway skyscraper is one of their most prosaic; it is constrained by awkward proportions, spare artistic details, and functional problems. The Transportation Building, erected on the northern half of the revered former Astor House, also suffered its location by proximity to the successful Woolworth Building, a fate not escaped in this book. The top of the Barclay-Vesey Building (page 114) is in the left background, comparing the era's most successful setback-style tower with one of its weakest. The dome of the post office is at right.

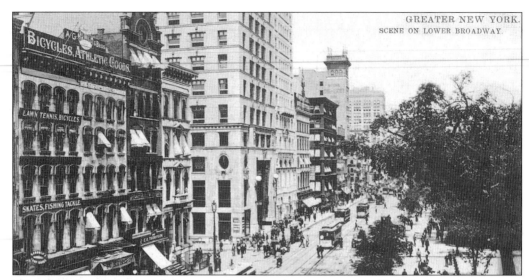

The west side of Broadway between Park Row and Murray Streets, likely built in the 1880s, is pictured at left on this *c.* 1905 northward view. Hall-of-Famer Albert G. Spalding had a fine career as a pitcher, but his sporting goods business spread his fame and built his fortune. One suspects he did not hear his name mispronounced "spaldeen," on the streets of New York for their popular pink rubber ball. The two blocks to the north are pictured on the next two pages. City Hall Park is at right.

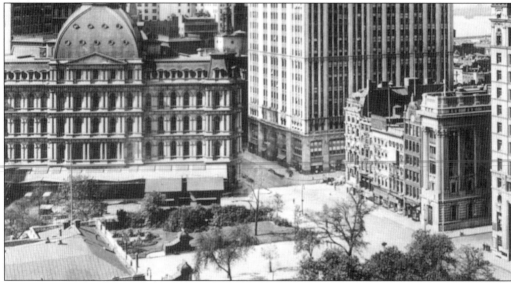

The slender Importers and Traders National Bank, designed by Joseph H. Freedlander and built in 1907 on a lot only 25 by 100 feet, is seen on the south side of Murray Street. This block, also at top and on the bottom of page 69, is pictured devoid of activity; it may have been photographed on a Sunday morning. The photographer's vantage was likely the roof of the Stewart-Sun building (page 128). The early Sun was important when lower Broadway was a major retailing street, giving preference to the west side, which was known as "the dollar side" while the less-desirable east side was disparagingly called "the shilling side" after the British currency once in use. The glass, nondescript office tower at 250 Broadway fills the block now.

The Home Life Insurance Company Building, located mid-block between Murray and Warren Streets at 256 Broadway, was the world's tallest office when completed in 1894. Napoleon LeBrun, winner of a competition, designed the 16-story, 287-foot-high building, topped with a steep mansard roof. The building is now occupied as offices of the City of New York, which joined it with the Postal Telegraph-Cable Building at left. Designed by Harding & Gooch, the Postal Telegraph-Cable Building was also constructed in 1894 and located on the northwest corner of Murray Street. Completed in 1900 and designed by John B. Snook, the Rogers Peet Building, at right, has an appealing copper cornice and detailed molding lost in the postcard image. The block is well preserved, but the buildings reflect the inevitable changes in street-level design, while the upper section of the entrance at left was filled by glass blocks.

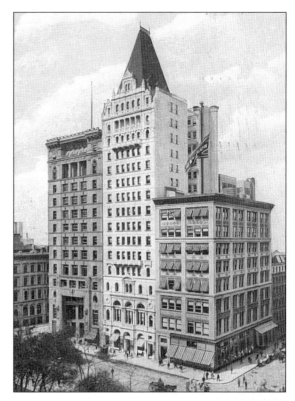

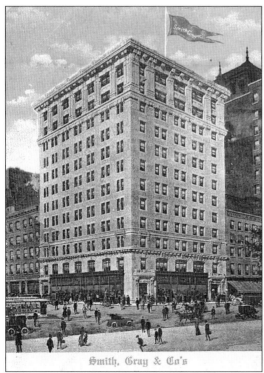

Smith, Gray & Co's

Smith Gray & Company's building at 261 Broadway, the northwest corner of Warren Street, was designed by James B. Baker and built c. 1906. The exterior is little changed, other than a relocated entrance and the removal of the cornices. The building was the first in the area to be converted for residential occupancy, c. 1980.

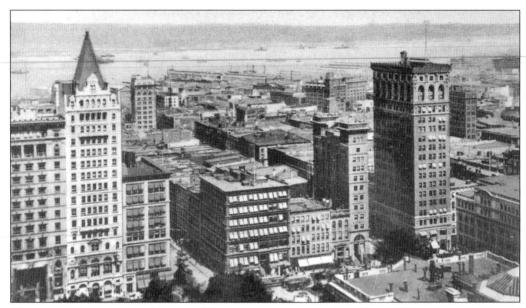

The corner, shown on the bottom of this page, appears at right in this *c.* 1905 Rotograph view of the west side of Broadway; the block on the top of page 73 can be seen at left. The United States Life Insurance Company Building is on the northwest corner of Warren Street, pictured here shortly before being replaced by the building on the bottom of the preceding page. The grocery business center was located north of Chambers Street, while an extensive wholesale dry goods business extended west and north to about Varick Street. (Courtesy of Saul Bolotsky.)

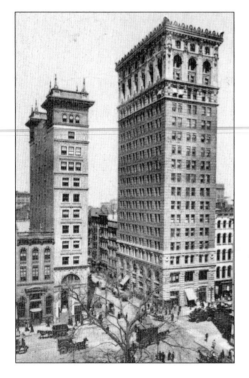

The Broadway Chambers Building, rising 18 stories on the northwest corner of its namesake intersection, was designed by Cass Gilbert and completed in 1899. One of his earliest offices, the terra cotta and brick-clad building is a Renaissance Revival example of the classic tripartite organization of base, shaft, and capital. Gilbert won a gold medal for the design at the 1900 Paris Exposition. The National Shoe and Leather Bank, an 1893 work by architect Josiah Cleveland Cady, filled the southwest corner. The Chemical Bank is adjacent. The Broadway Chambers Building stands, but the Arthur Levitt State Office Building, erected between 1928 and 1930, replaced the two banks.

Five

EAST OF BROADWAY

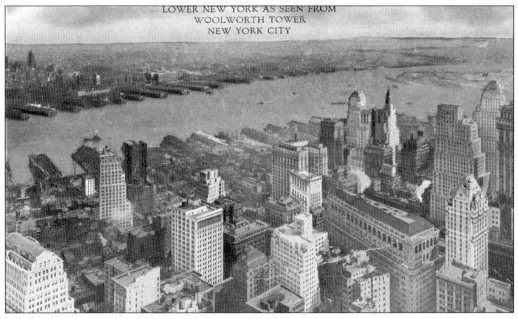

This *c.* late-1920s image from the Woolworth Building provides a fine view of the insurance district. Liberty Tower (page 28) in the lower right corner and the Federal Reserve Bank (page 79) to its left are well-known landmarks. Note also at the lower left the 20-story, 280-foot-high Royal Insurance Company Building, designed by Starrett & VanVleck. The stacks in front of the East River, at left, belong to the *c.* 1903 Consolidated Edison generating plant that was razed *c.* 1968 and replaced by 130 John Street. The building left of the plant is 111 John Street, a 25-story, 334-foot building designed by Ely Jacques Kahn. The smaller, pie-shaped structure in front of the Federal Reserve is the German American Insurance Company Building (page 76). The square-shaped building behind it is 80 Maiden Lane, completed in 1912.

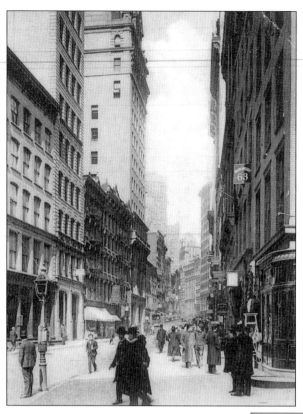

Maiden Lane has two charming legends of its name's origin. One depicts it as a lovers' lane, while the other claims the street was a gathering place for the girls' laundering activities in a stream along its course. The street had long been a retail center and had an active jewelers group by the second quarter of the 19th century. Most jewelers migrated in time, as the street assumed an office character by the 1890s. The Lawyers' Title Insurance Company completed the 12-story office at left. Designed by Charles C. Haight in 1895, it had a dormer and finial. The first awning marks the Myers Building at 48–50 Maiden Lane. In the 1890s, that firm claimed to have the largest stock and greatest sales of American watches. The view is north from William Street. The south side of the street, seen at left, was cleared in 1921 for the construction of the Federal Reserve Bank (page 79).

The German American Insurance Company building was completed in 1908 on a triangular lot at the juncture of Maiden Lane, William, and Liberty Streets. The 21-story, 282-foot-high building rested on substantial caissons 42 feet below the basement. At left, notice the columns on the base and the appealing overhanging cornice. The building was demolished in the early 1970s, its lot left clear for the installation of large sculptures. The juncture was named Louise Nevelson Plaza after the artist and was dedicated in September 1978. A glimpse of the Singer Building is in the rear.

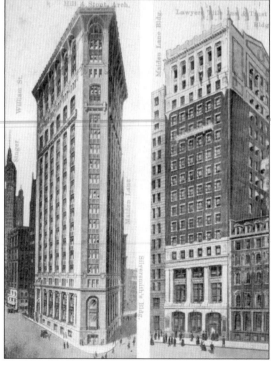

Liberty Street's curving course makes the Singer Building (page 62) at its northwest corner with Broadway appear to be placed over the middle of the street. The Chamber of Commerce Building in the center of this c. 1910 view is the only pictured building still standing. The block on the south is now occupied by the Chase Manhattan Building, while the Federal Reserve Bank stands on the north side at right. (Courtesy of Joan Kay.)

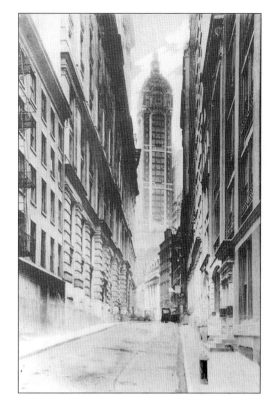

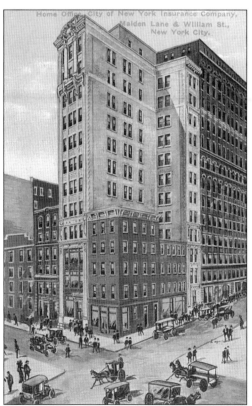

Most of the insurance industry moved north from the Wall Street area and took over much of the paint, drug, and chemical district. The origin of this new home office for the City of New York Insurance Company, located at the northwest corner of Maiden Lane and William Street (pictured in this c. 1910 postcard), is not clear. In time, the corner was expanded to a larger building that was connected with the building at right, which is on the southwest corner of John and William Streets. The two buildings were largely occupied by the Home Insurance Company. The buildings were demolished in the 1960s for the construction of a new Home Insurance Company Building, the structure still on the 59 Maiden Lane site.

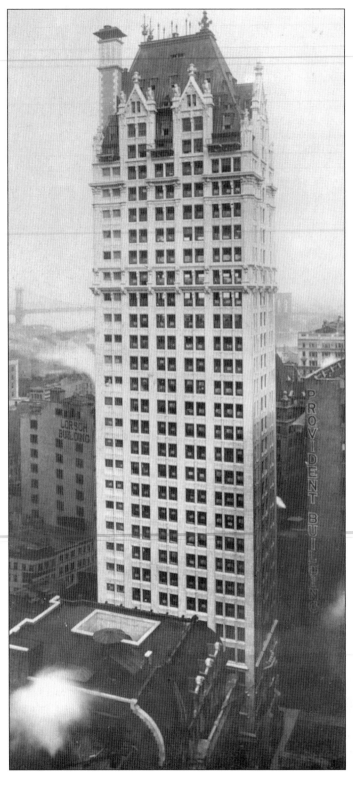

Architect Henry Ive Cobb's Liberty Tower, the area's second Neo-Gothic office project, was completed in 1910 at the northwest corner of Liberty and Nassau Streets. It followed the U.S. Realty "twins" on Broadway (page 55) by a few years. The 33-story, 400-foot-high, copper-roofed building was erected on a plot only 58 by 92 feet, an oddity that *Wonder City* described as "the tallest building in the world on so small an area of ground." Sinclair Oil made its headquarters here from 1919 to 1947. The tower was sometimes called the Sinclair Oil Building. Liberty Tower was adapted for residential use in 1979, the beginning of a trend that accelerated in the following decades. The Chamber of Commerce Building is in the foreground of this *c.* 1915 photographic postcard; it was probably taken from the Singer Building. Note its light court and how the photographer framed Liberty Tower with both towers of the Brooklyn Bridge. The Lorsch Building to the left was completed in 1896 at 37–39 Maiden Lane, a block that is now the site of the Federal Reserve Annex.

Organized in 1768, the New York Chamber of Commerce is the oldest group of its type and was, at one time, a powerful organization for the promotion of business. Its membership, limited to 2,000 people, was a roster of the city's power elite. In 1902, the chamber completed this headquarters at 65 Liberty Street, at the northwest corner of Liberty Place. The four-story, marble Beaux-Arts building with a mansard roof was designed by member James B. Baker. Their stature is indicated by the presence of Pres. Theodore Roosevelt at the November 11, 1902 dedication. The building's 90-by 60-foot Great Room, with a ceiling that rose 30 feet, was lined with oil portraits of members and was one of New York's greatest interiors. Its influence having waned long ago, the chamber moved out in 1980, selling the building some years later to the International Commercial Bank of China. The Great Room is intact as a banking floor (which the author observed only through a security monitor in the lobby), while the landmark exterior is preserved unchanged. This *c.* 1905 view looks west. A small, harmonious five-story building now stands adjacent to the chamber on the west, while the corner building (at top) that housed the Williamsburgh City Fire Insurance Company was replaced by the Westinghouse Building at 150 Broadway.

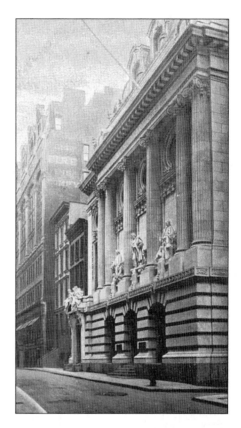

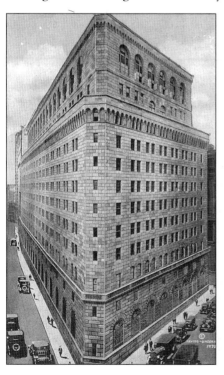

York & Sawyer, the foremost bank architects of their generation, won a 1919 competition for the Federal Reserve Bank of New York with their design of a 14-story building in the spirit of a 15th-century Florentine palazzo. The excavation, begun in 1921, proved difficult, hampered by narrow streets and the weight of surrounding buildings; its 5-story, 80-foot depth was the deepest in Manhattan at the time. The building—covering the trapezoidal-shaped block bounded by Maiden Lane, Nassau Street, Liberty Street, and William Street—was completed in 1924. It is clad in Indiana limestone and Ohio sandstone, the bicolored material intended to add interest to the plain facades. The building is richly ornamented by decorative interior and exterior wrought iron, including doors, lamps, and window guards from the forge of master iron worker Samuel Yellin of Philadelphia. The Federal Reserve, serving as a bank to both bankers and nations, largely includes offices above ground, but its five levels of underground storage vaults hold more gold than any other repository. The Federal Reserve led to widespread use of the Renaissance Revival style in bank design.

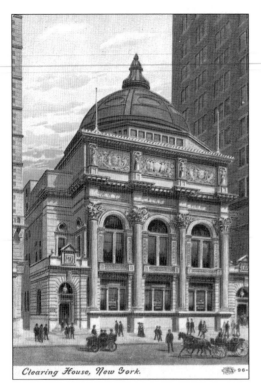

Clearing House, New York.

The New York Clearing House Association was organized in 1853 by 52 commercial banks to facilitate the daily settling of their accounts with one another. Privately owned and funded by fees levied according to volume, the association functioned in the manner of a central bank, also acting as a lender of the last resort to member institutions. Clearing operations were conducted in a large room under the dome, where bank settling clerks sat behind four long rows of high desks, receiving checks from delivery clerks or porters (to use their ancient name). Banks' claims against one another were settled and a daily proof made of their balances. Fines were levied for errors. Its headquarters at 77 Cedar Street, designed by Robert W. Gibson and built by Marc Eidlitz & Son, was completed in 1898. It was demolished for construction of the tower at 140 Broadway that now rests on the site. Although much of its function was assumed by the Federal Reserve System that began in 1914, the association still endures. The *c.* 1905 postcard belongs to one of the Illustrated Post Card Company's long numbered series of New York.

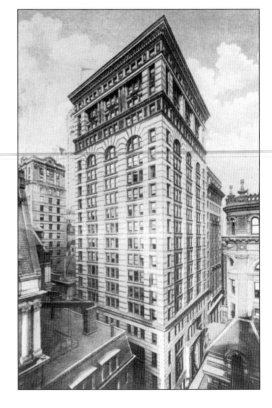

The Bank of Commerce Building was built c. 1895 at the northwest corner of Nassau and Cedar Streets on the site of their prior five-story building. The 20-story, 274-foot-high office was designed by James B. Baker during his short-lived partnership with Thomas Rowe. It is pictured c. 1910 across Cedar from the former Equitable Building, towering over the New York Clearing House to its left and across Nassau from Mutual Life, the taller building at right. This block was cleared in the mid-1960s for the construction of the tower now at 140 Broadway.

The Chase Manhattan Bank Tower is arguably the most important downtown post-WWII building. It is an outstanding example of the Skidmore, Owings & Merrill firm with Gordon Bunshaft as partner in charge. The 1955 announcement of Chase's plan to build a major headquarters was the prime factor in the reversal of a decline that threatened to end downtown as a financial center. The 60-story, 813-foot-high office was the sixth tallest in both New York City and the world when completed in 1960. The siting of the building is significant in addition to its design; the prominent aluminum vertical columns on the aluminum and glass-skinned building were the first in the financial district. The tower covers less than 30 percent of its plot on the block bounded by William, Liberty, Nassau, and Pine Streets. This permits its rectilinear massing that, together with the success of two midtown towers, led to the adoption of the 1961 zoning law that effectively replaced the setback style of construction. The postcard appears to be a c. 1960s Chase public relations issue. The view, looking southeast from the corner of Nassau and Liberty Streets, provides a glimpse of the varied color cladding of the Federal Reserve at left.

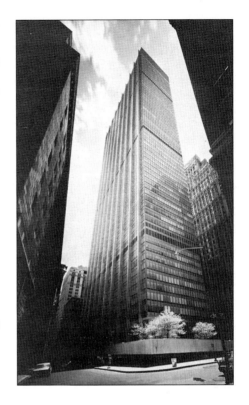

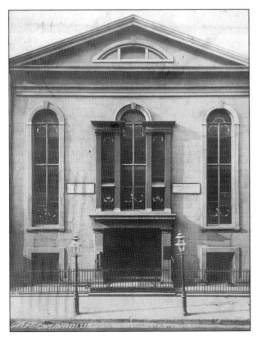

The John Street United Methodist Church, the oldest Methodist society in America, organized in 1766, erected its first edifice at 44 John Street in 1768, and rebuilt it in 1817 when John Street was widened. This 40- by 80-foot Georgian-influenced church, clad in brownstone, was built in 1841. Its design is attributed to Philip Embury. Stones from each of the predecessor churches were incorporated into the new one. The church considered selling the property before 1841 and again in 1854, when they contemplated a move to the Madison Square area. Forces seeking to preserve the John Street locale secured a New York State charter under which the General Conference elects its trustees. This move intended to secure perpetuation of John Street as a Methodist memorial. The facade has changed little. The plaques recounting the history of the site are adjacent to the Palladian window in this c. 1905 photographic postcard, but were later lowered to eye-level. The fence is gone, while the lower windows are now barred. The church maintains a museum that includes a collection of Methodist-related art.

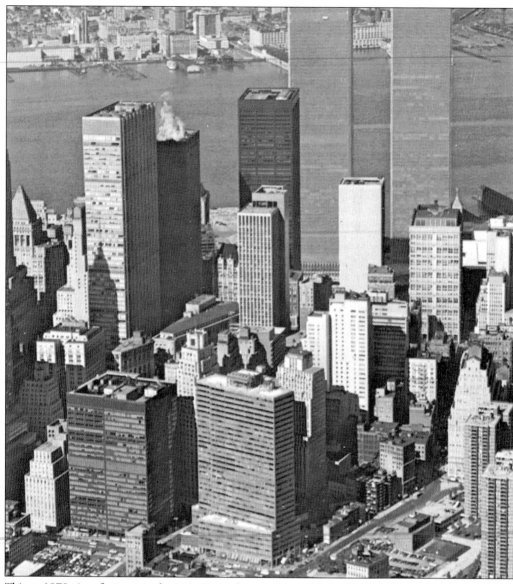

This *c.* 1970 view from over the East River shows Water Street, at bottom, in an early state of its development as an avenue of office towers, although the two buildings at the bottom left had John Street addresses when built. The square structure at left, No. 130, was erected *c.* 1970 on the power-generating site seen on page 75. It faces No. 127 that was designed by Emery, Roth & Sons and completed in 1971. That building included many whimsical decorative and design features, including an open lobby that has since been closed during its conversion to New York University dormitories. Its large digital clock, erected on an adjacent holdout building, faces Water Street and still operates. With Water Street having become a substantial office address, the two buildings are now known as 180 and 200 Water Street, respectively. The 1969 Southbridge Tower apartments at right, designed by Gruzen & Partners, replaced aging low-rise buildings from the area's mercantile and chemical district era. The tall towers seen here, from left to right, are Chase Manhattan (page 81), the dark 1 Liberty Plaza (which replaced the Singer Building; see page 62), and the twin World Trade Center buildings (pages 112–113).

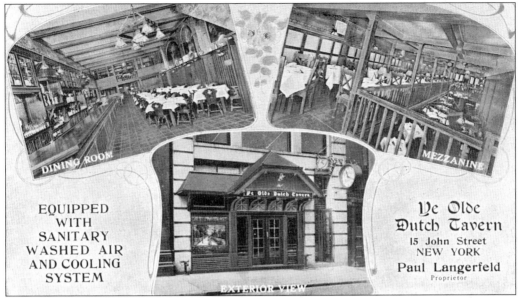

EQUIPPED WITH SANITARY WASHED AIR AND COOLING SYSTEM

DINING ROOM

MEZZANINE

EXTERIOR VIEW

Ye Olde Dutch Tavern
15 John Street
NEW YORK
Paul Langerfeld
Proprietor

Ye Olde Dutch Tavern was located on John Street since *c.* 1892, next to No. 15. It moved into building No. 15 *c.* 1917. The location was the site of the John Street Theater from its December 7, 1767 opening to around 1798. The tavern was known for its German cuisine. Indeed, the back of this *c.* 1940 white border postcard has a rubber stamp mentioning "sauerbraten and hasenpfeffer" among its specialties. The restaurant became a French-style brasserie in late 1999, but the interior, including the old bar, is readily recognizable. The clock is long gone and the historical marker commemorating the theater, once on the facade, is also missing.

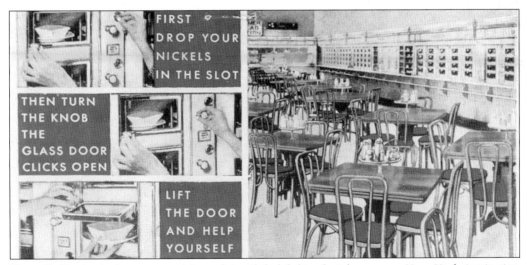

FIRST DROP YOUR NICKELS IN THE SLOT

THEN TURN THE KNOB THE GLASS DOOR CLICKS OPEN

LIFT THE DOOR AND HELP YOURSELF

Horn & Hardart's Automats originated in Philadelphia, but became a New York institution following their 1912 introduction in Times Square. The *c.* 1940s Lumitone postcard describes the operation that made a simple meal an adventure to a first-time visitor. The introduction of fast food restaurants was a major factor in the decline of Horn & Hardart's Automat. Some of its later downtown sites included Broadway, Park Row, and Nassau Street. Its fall was rapid from the late 1960s; the last, on Forty-second Street and Third Avenue, closed in 1991. (Courtesy of Charles Kleinman.)

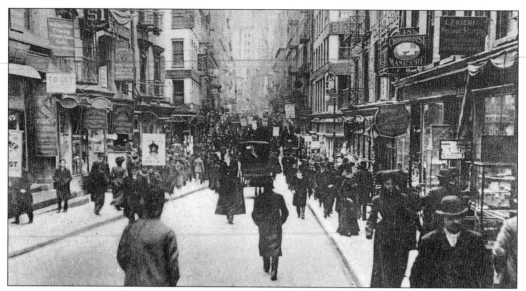

Narrow Nassau Street is the continuation, north of Wall Street, of Broad Street. This filled-in canal was named for the Dutch House of Orange-Nassau. When pictured by the Rotograph Company, north of Liberty Street, *c.* 1905, it was a busy shopping street, a character maintained to date. Note that urban signage was more interesting then, especially the optical sign at left. The building at right with the tall lettered signs is at the northeast corner of John Street, then the home of noted diamond merchants Randel, Baremore & Billings. (Courtesy of Charles Kleinman.)

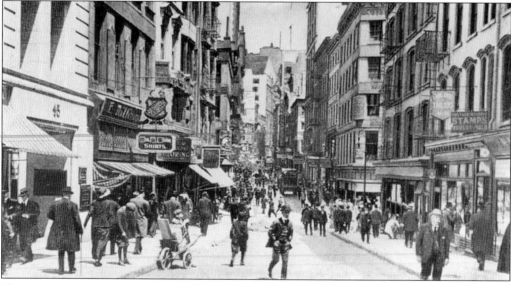

The same street as on top, seen *c.* 1920, shows only minor change. Forty-five Nassau Street, at left, was built on the northern edge of Liberty Tower. The "stamps" sign at left is worthy of note as Nassau Street was, for at least a half-century, synonymous with postage stamp dealing, both at shops and in above-grade offices. The block at right was demolished in 1921 to clear the site for the Federal Reserve Bank. The block at right-center, between Maiden Lane and John Street, has been filled with the Federal Reserve Annex since 1978 (Courtesy of Charles Kleinman.)

George B. Post designed the New York Cotton Exchange, built in 1883–85, following the success of his Produce Exchange (page 20). The building filled an irregular lot at William and Beaver Streets and Hanover Square with a three-story base. It contained a 35-foot-high business-trading room as well as offices (which paid a good rental income) built into two towers separated by a light court. The conical roof on the round tower faced William and Beaver Streets. Organized in 1870 and incorporated the next year, the Exchange both facilitated the trading of cotton and established and maintained industry practices, while adjusting controversies among members. The round tower, reminiscent of the 16th-century Chateau Chambord, provided a French Renaissance presence for the many period revivals that influenced American architecture in the late 19th and early 20th centuries. The Cotton Exchange replaced this home with the building seen on the bottom of page 88.

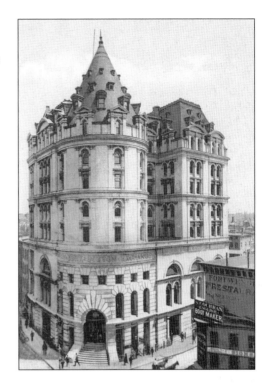

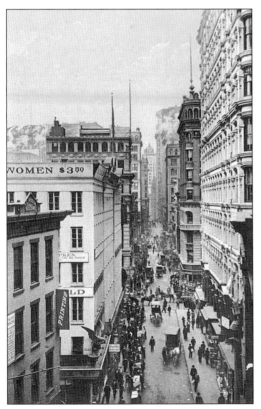

The Bennett Building, designed by Arthur Gilman, had seven stories and a mansard roof when completed in 1873. An 1894 expansion, designed by architect James M. Farnsworth, added four stories while removing the mansard. James Gordon Bennett, who had erected a building for his *Herald* one block to the north on Broadway and Ann Street, built New York's largest cast-iron building for rental income and named it for himself. Seen *c.* 1900, looking south on Nassau Street, the Bennett Building, located on the west side of Nassau Street between Fulton and Ann Streets, had used a 99 Nassau Street address. However, its entrance is now on Fulton Street and is named Fulton Center. The two buildings on the east side of Nassau Street are gone, the one in the foreground replaced by a grade-level extension of 116 Nassau Street, while a nondescript three-story structure has long been on the Ann Fulton block. The building at the left background is 90 Nassau Street, built *c.* 1890 and designed by De Lemos & Cordes. Residential conversion is planned opposite it at 87 Nassau Street.

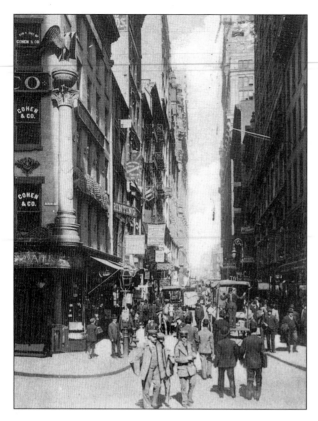

The building on the northwest corner of Nassau and Ann Streets, seen in this *c.* 1905 northward view, had origins as the 1829 type foundry of James Conner, whose firm was consolidated with a number of others into the American Type Founders Company in 1892. Its eagle and globe on the column are an appealing decoration, the bird a seeming companion for the one on the bottom of the preceding picture. The building standing on this corner at the beginning of the 20th century appears to be a replacement and was being cleared for renovation in early 2000. This street was the most active of the Nassau Street stamp dealing neighborhood. The tall building at right is 116 Nassau Street, the former Stamp Center, now the China Trade Center. Nassau Street is a pedestrian mall during busy shopping hours, so crowds that still rival those in this nearly century-old image no longer compete with the now motorized four-wheel vehicles.

The street seen above can be found in the lower left corner of an incredible 1920s photographic postcard depicting the intersection of Ann and Nassau Streets in the lower left corner. The Morton Building was later the Stamp Center. Under the Municipal Building (page 127) in the left background are two distinctive Park Row towers, the pointed Tribune's (page 122) and the domed World's (page 123). The American Tract Society (page 122) is beneath them, its light court visible on its south elevation. The pyramidal tower at lower left is Temple court, 5 Beekman Street. Some of the Ann Street buildings are among the low-rise survivors, but much of the area was built by the expanding facilities of Pace University and the Beekman–Downtown Hospital. The photographer was seemingly eye-to-eye with *Civic Fame* atop the Municipal Building and able to reach out to the pilot of the DH-4, the Army Air Corps' workhorse plane in the post–World War I decade. His perch was likely the top of the Equitable or Bankers Trust buildings.

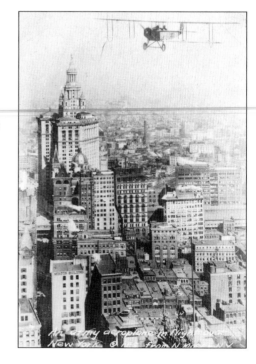

The lamps and cornice crest topped with a decorative pediment give a touch of artistic distinction to a modest mercantile building on the south side of Fulton Street, near Broadway. The decorative touches remain, but boarded windows, an open storefront, and shabby retail occupancies make this *c.* 1910 postcard a sad reminder of what was. It could also serve as a model for restoration. (Courtesy of John Rhody.)

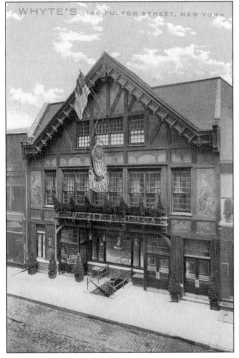

Whyte's Restaurant, founded by Edward E. White at 145 Fulton Street in 1909, maintained stature for fine dining and notable seafood until its closing *c.* 1970. Only subtle differences exist between the *c.* 1910 and *c.* 1950s exterior; however, a world of difference can be noticed in its 2000 appearance. Clinton & Russell designed the building to resemble an English village inn in the midst of a bustling street. The building has lost its inn character; the half-timbering and stucco were given a uniform painting, while large windows replaced the small panes. Two modest grade-floor restaurants and a second-story gym fill the building.

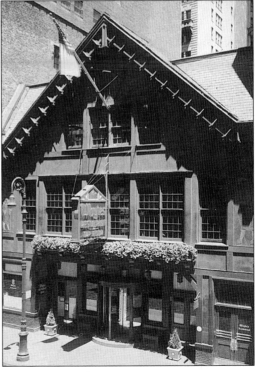

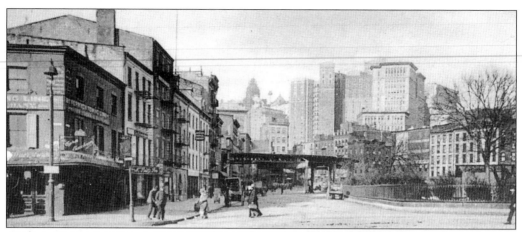

Coenties Slip, at South Street, a block north of Broad Street, is a former shipping slip, which was filled in 1835. The first City Hall was located here near the site of the elevated line, seen north of Jeannette Park in this 1905 Rotograph postcard. The latter was named by the New York legislature in 1884 in honor of the men lost on an ill-fated 1879 to 1881 Arctic expedition sponsored by James Gordon Bennett. Many four- and five-story buildings lined the surrounding streets into the 1960s; their numbers were reduced to a handful, as high-rise offices now fill this landscape. Most of the background belongs to the rear of Broad Street office buildings. (Courtesy of Joan Kay.)

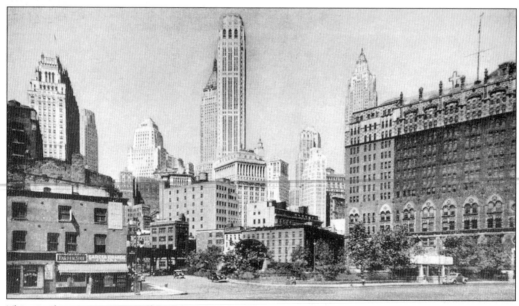

This similar perspective as the view at top, *c.* 1935, shows the Seamen's Church Institute, at right, and several skyscrapers, including 60 Wall Tower (page 43), also at right. The City Bank Farmers Trust Company (page 89) is prominent in the center, obscuring the taller 40 Wall Street (page 39), while under it is the 27-story Cotton Exchange, located at the southeast corner of Beaver and William Streets, designed by Donn Barber, and completed in 1923. The building, now 3 Hanover Square, was converted to cooperative apartments. The postcard was published by Lumitone, whose subjects included an extensive number of hotels and restaurants and whose work was typically characterized by soft colors. (Courtesy of Charles Kleinman.)

The City Bank Farmers Trust Building at 22 William Street, was completed in 1931 and was built in only one year by the George A. Fuller Construction Company. It covers an irregular, sloping, small 24-by 186-square-foot block, also bordered by Exchange Place, Beaver Street, and Hanover Streets. The building rises 54 stories and 760 feet. Cross & Cross's design artfully filled both a difficult site in regard to footage and the grade-floor requirement for two banks that needed separate entrances. The narrow tower was planned to maximize rental income. The architects' modern design claimed to follow no particular architectural style, but the building is well known for its Art Deco decoration. It also featured up-to-date mechanical amenities, including recessed radiators, under-floor ducts, refrigerated and ozonited water delivered to every floor, and high-speed elevators. The building was designated a New York City landmark in 1996. The view is from the William & Beaver corner, showing the Cotton Exchange in the right foreground. The Corn Exchange Bank Building, at left, provides an example of how the rears of buildings were often left unfinished; the rear elevation of its tower shows a plain brick cladding.

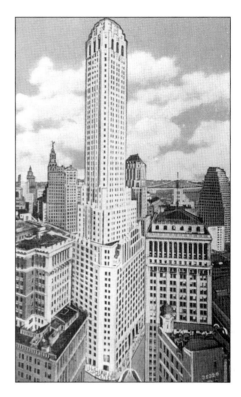

The slow speeds necessitated by trains traveling around the Coenties Slip S-curve gave riders on the elevated line a second-story glimpse of life in the financial district. The road at this point was a joining of the Second and Third Avenue lines, which terminated at South Ferry. It was torn down in 1955.

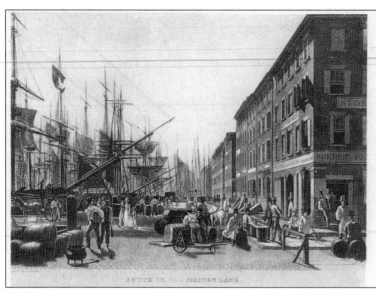

This historic print on a postcard issued by the New York Public Library shows a view of South Street, looking south from Maiden Lane. Drawn and engraved by William J. Bennett *c.* 1828, it published in *McGarey's Street Views in the City of New York*. The *Leeds*, the Swallowtail packet in the foreground, was later wrecked in the Thames. South Street was then an active commercial center, a time when mercantile activity in New York City was on the rise following the 1825 opening of the Erie Canal.

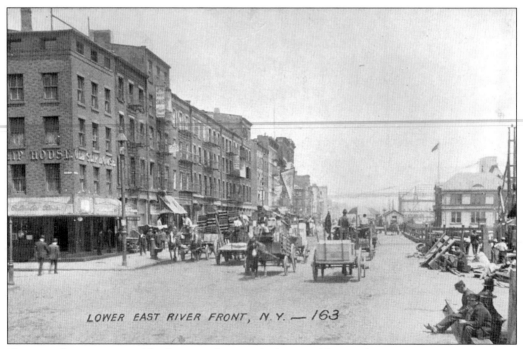

LOWER EAST RIVER FRONT, N.Y. — 163

The waterfront is pictured looking north towards the Brooklyn Bridge, *c.* 1905.

90

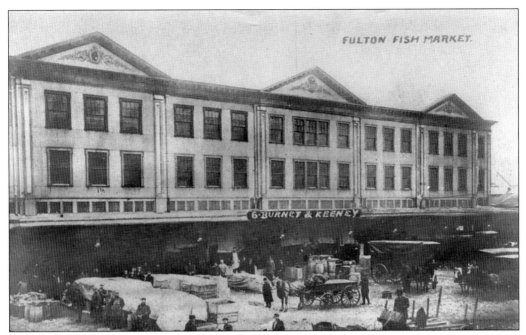

Fish dealers were located in part of the Fulton Market before the fishmongers set up their own riverfront shed in 1831. This *c.* 1910 postcard appears to be the permanent building erected in 1869. (Courtesy of Joan Kay.)

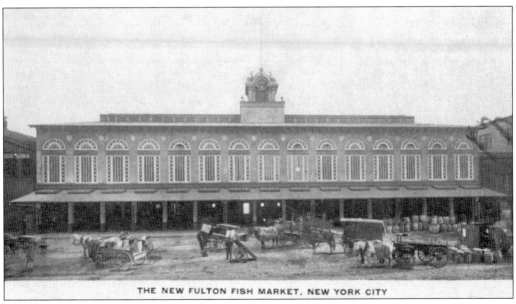

This building is an early-20th-century reconstruction of the 1869 market. Although express railroads extended the early-20th-century range of the market to a considerable distance, distribution by horse appeared to be local.

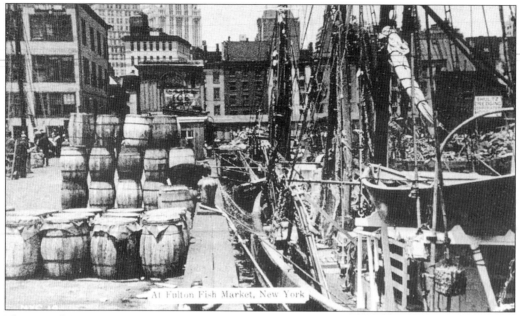

At Fulton Fish Market, New York

The waterfront was more active and colorful when the market's own fleet would arrive in port and unload its catch. The long tradition of boats leaving their catch at the market ended during the 1970s.

The Fulton Fish Market is still a thriving wholesale seafood market. Trucks now bring in and haul the fish. The market remains quite active in the late-night and early-morning hours. During the day, the buildings stand silent in the shadows of the gentrified South Street Seaport, an eating and shopping area that had its genesis in the maritime tradition established by the working fishermen.

East River docks, located south of the Brooklyn Bridge, are viewed c. 1900, near the site of the former Fulton Ferry. Pier 18 now exists as a corrugated metal structure north of the fish market. The challenge of tracing the history of piers includes changing structures (wood and metal being corroded by the elements) and changing users. Will the barrel truck please get out of the way of the horse-drawn streetcar? The postcard is a c. 1905 RaphoType, published by Raphael Tuck & Sons, in their series No. 5384 New York.

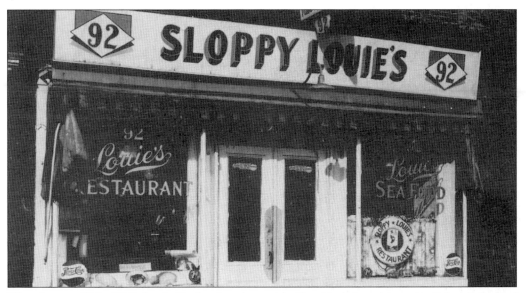

When he was 17 in 1905, Louis Morino immigrated to New York from his native Relco, Italy, and found restaurant employment. In 1930, he bought from John Barbagelata the Fulton Restaurant, also known as Sloppy John's, and renamed it Louie's Restaurant. A fishmonger called it Sloppy Louie's, the name sticking in spite of, or perhaps because of, Morino's initial protestations. Seating 80 on benches over a sawdust-covered floor, the place was, in a word, sloppy, but in a manner adding cachet, a quality that was lost after it was spruced up for the gentrification of the area. Sloppy Louie's, a culinary connection with the old market, closed c. 1998.

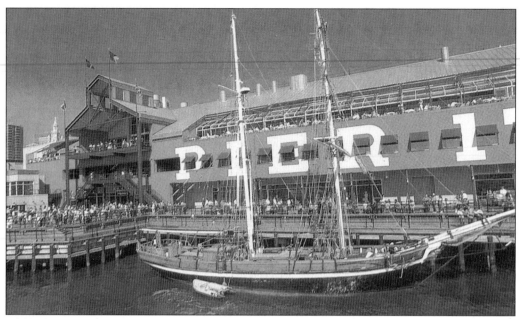

The South Street Seaport Museum, which began in 1967, was a major force in redeveloping the South Street Seaport area. It was a project built by the Rouse Company of Columbia, Maryland, with city, state, and private funds. Both the Fulton Market Building and Pier 17 are filled with shops (even some with maritime themes) and restaurants. The contemporary chrome was photographed and published by Gail Greig.

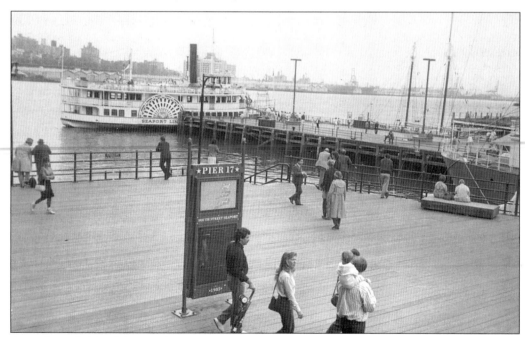

A number of old exhibition ships are open to visitors at the South Street Seaport Museum. The seaport has run various tour boats in local waters for some time. The sidewheel steamer was photographed by John Kowalak in 1985.

MAIN DINING ROOM
Sweets Restaurant
NEW YORK'S OLDEST SEAFOOD RESTAURANT

Sweet's Restaurant, occupying the second floor of 2 Fulton Street and claiming to be New York's oldest seafood restaurant, also had the reputation as one of the best. Established in 1845 and pictured on this *c.* 1940s linen postcard, a 1961 area history quoted an ancient customer: "little has been changed except the bulbs." Abraham Sweet opened his restaurant a few doors down the street and was at No. 2 by 1871. A 1940s restaurant guide remarked, "The bar is a curio, and so are the Negro waiters. When they set down a plate of fresh-opened oysters or clams in front of a customer, they believe he's going to like the tangy flavor, and they aren't guessing." The place closed in the early 1990s. An Ann Taylor clothing store now occupies the space, so visitors can feel they are in "Anyplace, USA" rather than a once dirty, smelly street.

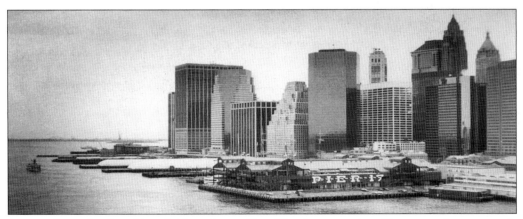

A view from the Brooklyn Bridge shows Pier 17, also opposite. However, the museum's exhibition ships are out of view, except for the tall masts of the bark *Peking*. The new Water Street office towers are depicted, with the setbacks of 120 Wall Street, the only waterfront building also on the bottom of page 96. The Statue of Liberty is discernible in the background. A John Kowalak photographic postcard, *c.* 1985.

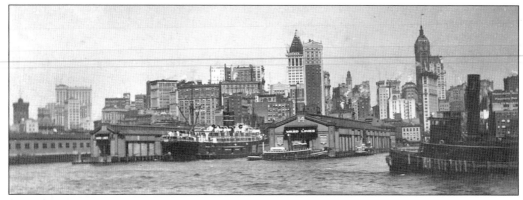

This photographic postcard looking west from the East River was postmarked in August 1911, but the construction activity at the pyramidal roof of the Bankers Trust Building (completed 1912) also provides a dating aid. Above the tugboat's bow are two recognizable towers: Singer (page 62) and Liberty (page 78). Below, the latter is the less-known flatiron-shaped German American Insurance Company Building, located at Maiden Lane, Liberty Street, and William Street (page 76). Many of the taller buildings at left are on Broad Street. The Whitehall Building (page 15) is at far left.

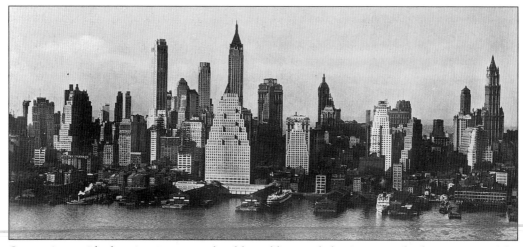

Comparison with the picture at top should readily reveal the Singer and Liberty towers. The northerly reach of this image extends to the Woolworth and Transportation Buildings, right (page 71). Left of Singer are two offices, a light setback-style building in front of one with round windows on its top floor, Nos. 100 and 80 Maiden Lane, respectively. The absence to their left of the Cities Service Building (60 Wall Tower; see page 43), completed in 1932, dates the picture as 1931 or 1932. The City Bank Farmers Trust, completed in 1931, is the tall tower to the left. Perhaps the most prominent building is the setback-style office along the water in the center, built on the site of Murrays Wharf, where George Washington landed April 23, 1789 to take his oath of office. The building is 120 Wall Street, a 36-story, 430-foot-tall office building completed in 1930. Designed by Ely Jacques Kahn, it was built by the General Holding Corporation on an irregular lot that widens at the north toward Pine Street. Two new buildings on lower Broad Street are at left: No. 80, nearer the edge, and No. 75, the ITT Building (page 44), to the right of it. Forty Wall Street (page 37) is the tower in center. Replicate the view today by a drive on the Brooklyn–Queens Expressway or, preferably by a walk on the Brooklyn Heights Esplanade (Promenade).

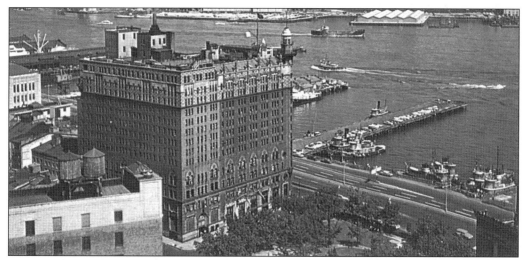

The Seamen's Church Institute is a shore center for active merchant seamen that was founded in affiliation with the Anglican Church. Beginning in 1834 as the Young Men's Auxiliary Missionary and Education Society, the institute launched a floating, Gothic Revival-style chapel in 1844. Their 25 South Street headquarters was built in 1908 and expanded *c.* 1929. The sympathetic addition is readily detectable by brick shading, visible in this 1950s chrome. The building was demolished *c.* 1968 for the erection of the office at 55 Water Street. A memorial to the victims of the *Titanic* disaster, which is shaped like a lighthouse, was placed on the northeast corner of Fulton and Water Streets, at the South Street Seaport. The memorial is visible on the southeast corner of the roof.

Hotel Lobby, Seamen's Church Institute of New York, 25 South Street

The institute sought to combat the ills of sailors' boarding houses by a variety of facilities for the welfare of seamen, including a home away from home and lodging at cost. A new home was built on Water Street, designed so it could be converted to a hotel in the event the place was no longer needed for its intended purpose.

Ye Olde Chop House was located for many years at 118 Cedar Street and may have been founded *c.* 1800 as an American replication of an English grill. It had a reputation as a men's eating place, a 1925 writer claiming that "there is a proximity between cooks and clientele which unfits it for the refinements of feminine entertainment". He added, "The tiny interior is divided fore and aft, the first portion again divided by an aisle, on one side of which is the oyster bar where on the other side are small tables for two a passage—mind the steps—leads down into the back room, a pleasantly gloomy chamber divided by stalls over which, from the ceiling, hang marine relics, harpoons, lanterns, an old ship's model and a goggle-eyed fish studded with cruel spikes." Loss of its building forced the business to relocate. (Courtesy of John Rhody.)

Old timers claim that Ye Olde Chop House lost much of its character after the move to the basement of the Trinity Building. They rehung their numerous amusing prints, "dating back to other generations and displaying the Light Horse cavalry of New York and historic prize fights between Black Mose and English Sikesby." Its distinctive menu featured game in season. Its closing in the 1970s was a regrettable lost link with old New York. (Courtesy of Saul Bolotsky.)

Emil Gerard's café, restaurant, and wine cellar at 92 William Street, seen on this *c.* 1930s white border postcard, is a charming model for a designer seeking to replicate old New York. The building was taken down to its steel skeleton in the mid-1960s, rebuilt, and renumbered 90 William Street. It houses a variety of insurance tenants for decades. The building was rewired in the late 1990s in the "Plug 'N' Go" program designed to attract technology tenants. A banner hanging in early 2000 proclaimed a new address of 1 Silicon Alley Plaza. Today, an actual plaza is the last thing one needs in New York to call a building's location a plaza.

The most interesting of the five views depicted by La Chorrera Restaurant in this *c.* 1930s white border postcard is the building. It reminds one that Water Street, into the 1960s, was lined with small brick buildings, which had long served nearby maritime trades and other mercantile occupancies. (Courtesy of Joan Kay.)

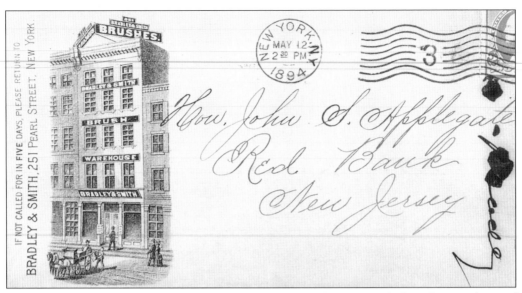

The illustrated envelope served one function of a postcard for decades before the popularity of the latter, showing the sender's place of business. The knowing searcher can find the former 251 Pearl Street building on the aerial below; it is in the row south of the southeast corner of the light building, near the center of the image. The Bradley mentioned above is James S., who gained considerable renown in New Jersey as the developer of Asbury Park. (Courtesy of Glenn Vogel.)

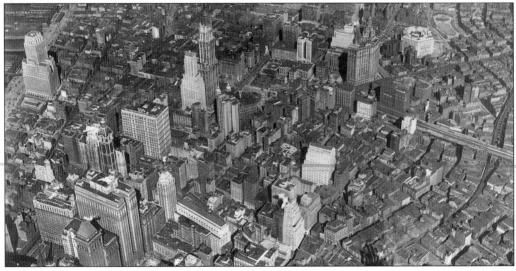

The building described at top is the Royal Insurance Building at the northeast corner of William and Fulton Streets. The cupola, at top right, is the Municipal Building (page 127), which stands over a now-closed Chambers Street (the book's northern border). The Woolworth Building (page 70) is the tall one left of center. Below it are the twin cupolas of the Park Row Building (page 123). The photograph shows the building's odd plan to accommodate two light courts. The Barclay-Vesey Building (page 114) is at far left. The site of the World Trade Center is below it. The hugeness and H-shaped plan of the Equitable Building (page 58) can be seen at lower left. The c. 1933 photograph depicts many of the low-rise mercantile and manufacturing buildings then at the fringe of the financial district, which have been replaced over the decades by offices.

Six

WEST OF BROADWAY

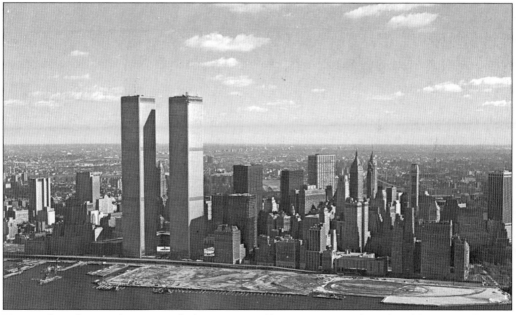

New York real estate has generally been an excellent investment, but the old saw justifying it, "they are not making any more land," does not apply in lower Manhattan. There has been a long tradition of filling in the waterfront when more land was needed, a process well illustrated in dioramas at Castle Clinton National Monument. Most land south of Bowling Green is made of fill. In the past generation, fill from the World Trade Center excavation was used to form an enormously valuable tract, seen here as vacant land, and as built-upon land on pages 112–113, along the western shore that had been occupied by a long row of obsolete and no longer needed piers. They are seen on the following page.

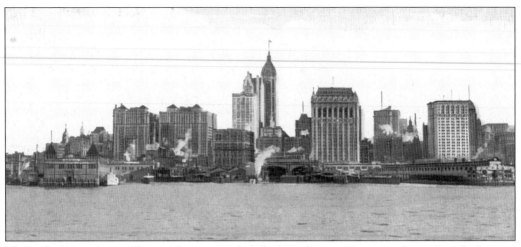

The piers lining the Manhattan shore provided dockage for every variety of vessel, including ferries, coastal steamers, ocean liners (which also used Hoboken, New Jersey), and railroad lighters (which brought in freight that ended its rail run in New Jersey). Images of the shore trace the changing skyline. The Singer Building with the City Investing office under it in the center (page 62) are the tallest structures in this Leighton & Valentine c. 1910 postcard. The twin buildings, at left, are the massive Hudson Terminal (page 108). If it had been built by then, the Woolworth Building would have been at far left. This interesting view is poorly printed, but illustrative of the deteriorated product of the late postcard era, which often resulted when a fine overseas publishers, Valentine, was forced to print in the United States with a marginal American partner, Leighton.

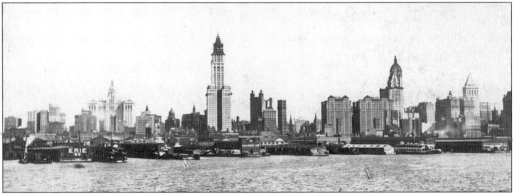

A photographic postcard hand-dated October 19, 1912 captures some of the scene at top. The Hudson Terminal–Singer Building–City Investing subjects are moved to the right, while the eye is drawn to the Woolworth Building (page 70) in the center. Construction scaffolding at top and the light court on the west elevation of its base (infrequently seen, as the building is usually photographed from Broadway) are visible. At left, the U-shaped plan and tower of the Municipal Building (page 127) are readily visible, while the three roof points between the two aforementioned buildings are Home Life (page 73), the World (page 123), and Tribune (page 122) Towers. The twin towers of the Park Row Building (page 123) are easily spotted, while even the belt courses of the St. Paul Building (page 66) can be detected, the two left of the Woolworth Building and separated by the Evening Post Building (page 68). The pyramid of the Bankers Trust roof is at right. The stacks of a Fall River Lines coastal steamer can be spotted, as well as ferries of the Erie and the Lackawanna Railroads, which were then separate lines.

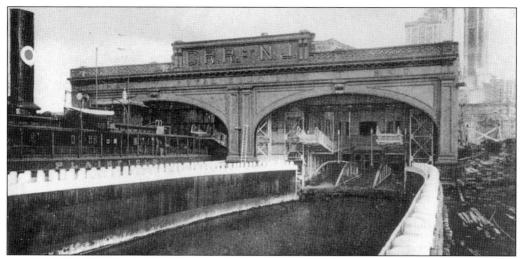

The Central Railroad of New Jersey (CNJ) extended its line from Elizabethport to Jersey City, *c.* 1864. It acquired land for ferry terminals on both sides of the Hudson River and built its New York dock at Liberty Street. It was the site of the first steam ferry, Robert Fulton's *Jersey*, which carried its first passenger on July 2, 1812. The crossing took about ten minutes. The CNJ named its vessels for towns on its rail lines. The *Plainfield*, seen docked, was built in 1904 by the Crescent Shipyard Company in Elizabeth, New Jersey; it carried 1,800 passengers and 20 automobiles. The line was in service until *c.* 1967, when the Aldene plan changed the terminus of the CNJ rail service from Jersey City to Newark, sending New York–bound passengers to their destination by the Port Authority Trans Hudson (PATH) trains. (Courtesy of John McGrath.)

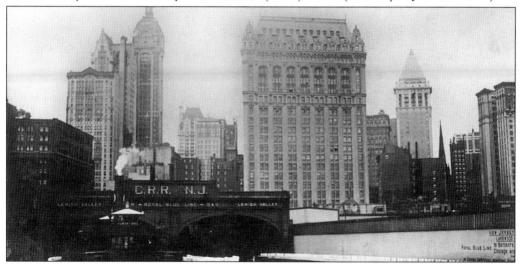

The West Street Building (page 116) is prominent in the center, a reminder that this structure was expected to be better seen from the water (especially the harbor entrance to the river) than from its surrounding streets. Note the advertisement on the ferry slip for the Central Railroad's Royal Blue Lines, a service offered in conjunction with the Reading and other lines for long-distance travel. It should not be confused with their later, legendary Blue Comet train. The Trinity spire is right of the Bankers Trust pyramid and left of a tiny, short-lived, 30- by 40-foot, 18-story tower on the southeast corner of Wall Street and Broadway (page 56). The Empire Building (page 23) is at far right.

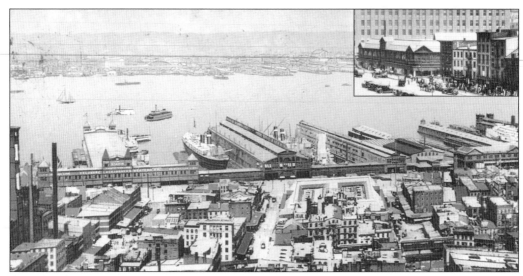

West Street runs along the water, while the low square building in the center is the Washington Market between Fulton and Vesey Streets. The Smith McNeill Hotel is in front of it on Greenwich Street, where the elevated line can be discerned, its spotting aided by a train over Vesey Street. The stacks at left were part of the New York Steam Heating Company plant on Dey Street. The postcard has an undivided back, predating March 1907, leading one to suspect the unfinished Hudson Terminal was the photographer's vantage. The World Trade Center covers this landscape now. The inset is the market about 20 years later and the block from Fulton to Dey Streets, a detail of a postcard of a nearby building. (Principal postcard courtesy of John Rhody.)

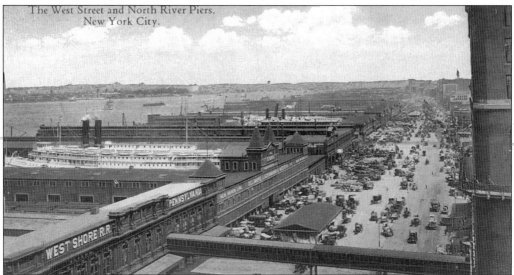

A 200-foot-wide West Street was so often congested with trucks (horse-drawn in the early days) that ferries built pedestrian bridges for their passengers. One such bridge is visible in front. The Central Railroad office on the northeast corner of Liberty Street is the partial glimpse of a building at right. The docks are gone, their space filled with Battery Park City landfill. This image includes the site today of a variety of construction, including a number of apartment complexes built to the north. A new span, the Tribeca Bridge, provides a crossing over West Street; it would be in the distance, north of Chambers Street, near the top of this c. 1905 view.

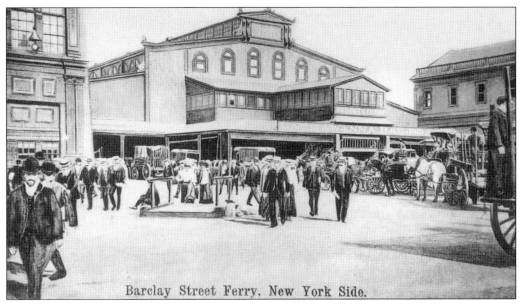

Barclay Street Ferry. New York Side.

The Lackawanna Railroad ran its ferries from Hoboken, New Jersey, to Barclay Street, named for the Reverend Henry Barclay, the second rector of Trinity Church. The dock site is now filled in. It is now the location of an Embassy Suites Hotel scheduled for completion in 2000. (Courtesy of Joan Kay.)

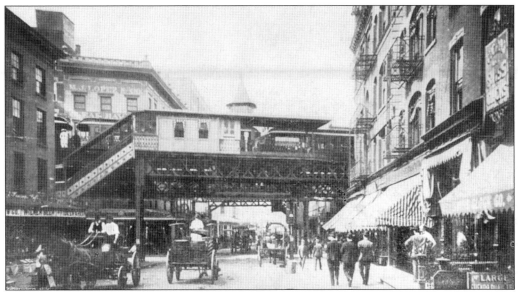

The Ninth Avenue Elevated station at Barclay and Greenwich Streets is seen c. 1905. Notice the nearby streets are filled with the four- and five-story buildings that once characterized the area. The direction of this view is not clear, but the area, especially the Barclay stem west of Greenwich, has been totally transformed. Washington, the next street running north–south, was cut off. Its course is the site of a tall glass tower on the north side of Barclay Street and a pedestrian mall on the south side. The rail line was razed in 1940. (Courtesy of Stephen Zussman.)

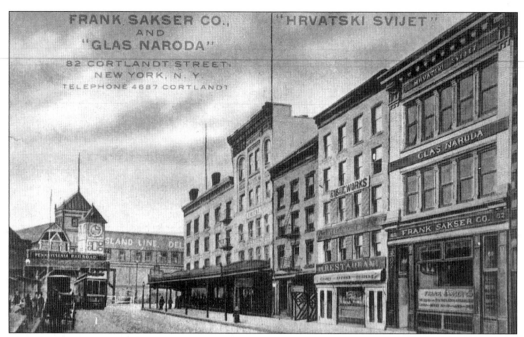

The Cortlandt Street block west toward the ferry terminal depicts an appealing clock tower. The Van Cortlandts were among New York's earliest settlers and this street was cut through their former estate. Its western stem, including this and the next two illustrations, are now covered by the World Trade Center. (Courtesy of Joan Kay.)

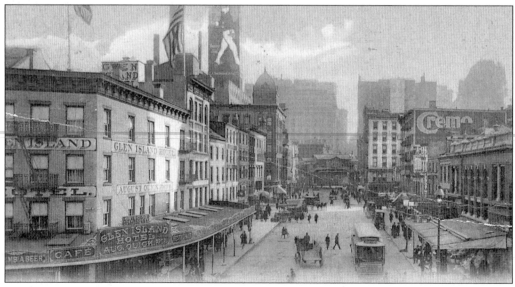

Cortlandt Street, looking east c. 1905, was photographed from the upper level of the Pennsylvania Railroad ferry terminal and published on a soft-color Rotograph postcard. The Glen Island Hotel on the northeast corner of West Street, presumably named after or connected with the Glen Island Line that docked across the street, was one of several in the area. However, the history of New York's hospitality business has been inadequately recorded. The small mercantile businesses that lined Cortlandt and surrounding streets are usually not well-recorded either.

This *c.* 1912 view (about one block east of the one pictured on the bottom of page 106) shows a greatly changed Cortlandt Street landscape. A Hudson Terminal building on the north side and City Investing on the south (with the adjacent Singer Building above it) gave the street a new look that would endure until the 1960s. The Ninth Avenue Elevated line at Greenwich Street is in the background.

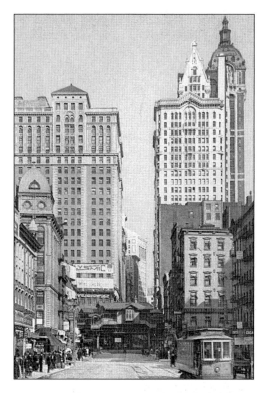

A 1986 photographic postcard by John Kowalak, taken from the west side of West Street, shows the modern towers of Broadway. The West Street Building (page 116) is at far right, behind the bridge leading to the World Financial Center. The United States Steel Building (1 Liberty Plaza) is at left, obscuring Liberty Tower, which is in front of the Federal Reserve Bank. Left of the latter are 140 Broadway and the Chase Manhattan Tower. The Marriott World Trade Center Hotel is now in the left foreground area.

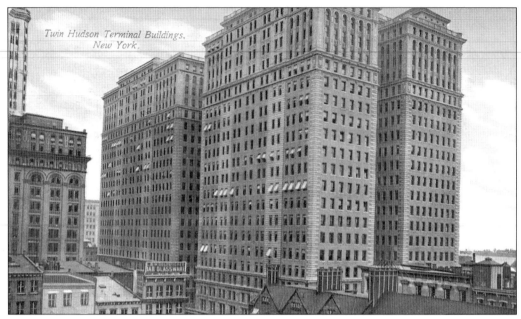

Twin Hudson Terminal Buildings. New York.

William G. McAdoo accomplished the remarkable engineering feat of tunneling under the Hudson River for the Hudson & Manhattan Railroad Company line, which officially opened on February 25, 1908. Its second line, connecting Exchange Place, Jersey City, and Cortlandt Street, was completed the next year. Over its station, H&M built two Renaissance-style, 19-story, 275-foot-high office buildings designed by Clinton & Russell. The huge block-long cubes were the largest offices in area when completed. They were also the heaviest and rested on the largest cofferdam ever made: 400 by 178 feet and 75–98 feet deep. The view, east of Church Street, looks southeast and shows the Havemeyer Building, designed by George B. Post, at left.

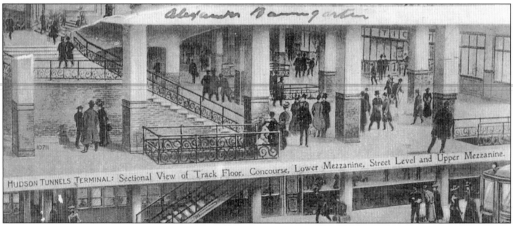

HUDSON TUNNELS TERMINAL: Sectional View of Track Floor, Concourse, Lower Mezzanine, Street Level and Upper Mezzanine.

The rail tunnel, three levels under the building, carried trains via a five-track loop, which entered the platform areas around sharp curves that produced ear-splitting screeches from the wheels. The station was relocated during the construction of the World Trade Center; wider curves entering the new station reduced wheel noise. The H&M entered bankruptcy in 1962. Its rail operations were taken over by the Port Authority of New York and New Jersey, which upgraded deteriorated rolling stock and facilities. The line, known since its beginnings as "the Tubes," took the new name of PATH.

Wonder City claimed that Hudson Terminal was not a mere building: "The immense sub-basements and arcades constitute a veritable city, with their varied shops, stores, counters and sales places, vending most everything desired from fruits, books and candy to wearing apparel, hardware and household items." Although these facilities were novel in 1908, the terminal's favor declined from a lack of amenities perceived necessary by later standards. The buildings were demolished for construction of the World Trade Center. (Courtesy of Cynthia Harris.)

The Cosmoplitan Hotel reportedly has *c.* 1845 origins as a four-story boardinghouse for the mercantile trade. It was expanded to its present six stories *c.* 1869 by its new owners, N. and S.J. Huggins, who gave it the present name. The place has had a number of names—including the Girard House, the Frederick, and the Bond Hotel—and various incarnations, recently as a single-room occupancy residence. This *c.* 1910 postcard, which advertised rates on the back, shows a structure amazingly little-changed 90 years later; only the balconies are gone. The Cosmopolitan Hotel was renovated in the mid-1990s. This modernized facility, in proximity to the World Trade Center, is appealing to a business and European traveler clientele.

109

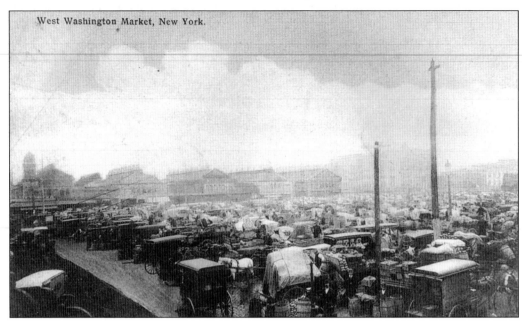

A food market was established on Washington Street by the end of the 18th century. The term "Washington Street Market" applied both specifically to the market (built in 1812 and rebuilt in 1884; see page 104, top) and to a wholesale produce market that lined Washington Street from Vesey Street north to N. Moore Street. The area was cleared for urban renewal projects and replaced in 1967 by the Hunts Point Market in the Bronx. (Courtesy of Joan Kay.)

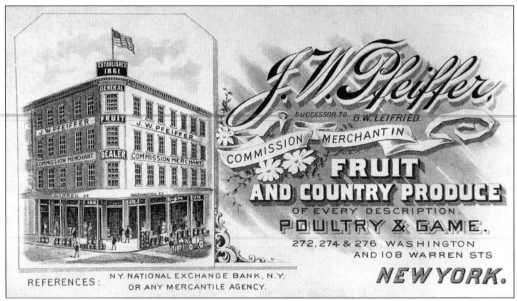

The Washington Market conveyed an aura of old New York through its final years, particularly at night, when waste wood fires in old drums glowed. Rows of old brick buildings stood witness to the process of sending income to growers while feeding a metropolis. Pfeiffer's example was more likely a trade postcard, rather than one to be mailed. (Courtesy of Joan Kay.)

110

An advertising postcard, *c.* 1910, gives a face to one of the many merchants that filled the four- and five-story buildings on the western edges of the financial district. The back of the postcard indicated that French also did repairs. The street was cleared for the World Trade Center. (Courtesy of Joan Kay.)

Many radio and electronic stores clustered in the blocks west of Hudson Terminal, giving the neighborhood the informal, but widely recognized nickname "Radio Row." The area was perhaps genteel shabby, but presentable, and the aggregation of similar businesses attracted hobbyists and tinkerers from a wide distance. Radio Row was obliterated by land acquisition for the World Trade Center. Signs on Cortlandt Street near Greenwich indicate an area on the move, while two cleared blocks are plainly visible to the west in this John Kowalak photographic postcard.

Plans of the Port of New York Authority (before New Jersey was added to the name) to erect a massive office complex that would include the tallest skyscrapers ever built were met with strong opposition by New York real estate interests. They were justifiably fearful the project would overwhelm the downtown rental market, which during cyclical declines, could have uncomfortably high vacancy rates. They announced the 10-million-square-foot project before the site was selected, but initially projected an east side locale. In 1962, the Port Authority chose Minoru Yamasaki as lead architect, working with Emery Roth & Sons. The World Trade Center is bounded by Liberty, Church, Vesey, and West Streets. The project would be dominated by two 110-story towers, seen at left in a model. They would rise to 1,362 and 1,368 feet (100 feet taller than the Empire State Building) over a large plaza, accompanied by a number of smaller buildings. The Port Authority's aim was to bring the international trade community together.

The massive excavation preceded difficult foundation work on the marshy land, which required engineers John Skilling and Leslie Robertson to devise an ingenious technique to sink a foundation to bedrock 70 feet below the surface. World Trade Center dredging began the Battery Park City landfill project (seen vacant on page 101 and here, in front of the towers, during construction) and accounted for 25 of its 92 acres. The towers, each over 200 square feet, were constructed from the core to their external steel skeletons. The towers dwarf everything around them. Note surrounding mainland structures: the West Street Building (page 116) at right and the Barclay-Vesey Building (page 114) at left. Criticism typical of the towers' early years has largely been forgotten as they have added a dramatic image, particularly at night, to the downtown skyline. This 1980s image is a John Kowalak photographic postcard.

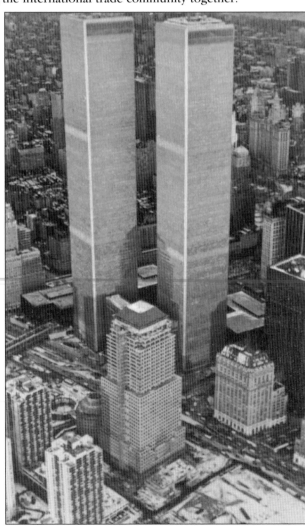

Gail Greig's camera framed the Woolworth Building with the towers of the World Trade Center. Their windows, only 18 inches wide, were set between 18-inch-wide columns, which are sheathed in aluminum alloy that projects 12 inches from the surface of the glass. The windows cover only 30 percent of the buildings. About 8,000 people live in Battery Park City, many in the foreground Gateway Plaza apartments, the first substantial construction there. The World Financial Center office under the south tower is topped with a mastaba, an Egyptian-style tomb structure. (Courtesy of Gail Greig.)

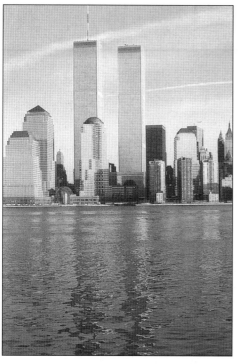

The World Financial Center was designed by Cesar Pelli, developed by Olympia & York, and built between 1985 and 1992. It cost $1.2 billion and provided 6 million square feet of office space over 13.5 acres of Battery Park City. Its four towers range from 34 to 51 stories. Two are left of the World Trade Center in this image by photographer and postcard publisher Gail Greig, while a third is in front of the north tower. A fourth tower, also seen at top, is behind the Gateway Plaza residences. The break in the waterline is the North Cove boat docks. The dome left of the World Trade Center is the Winter Garden, a 125-foot-high, glass-enclosed atrium. (Courtesy of Gail Greig.)

New Telephone Building, West Street, New York City

The New York Telephone Company built this headquarters–operations building at 140 West Street. Alternately called the Barclay-Vesey Building for its side streets, the 54,696-square-foot plot also covered the block bordered by Washington Street. The design was an early work by Ralph Walker, architect in charge at McKenzie, Voorhees, & Gmelin. The 34-story, 398-foot-high building was hailed as the first artistic interpretation of the setback requirements of the 1916 zoning law when completed in 1926. When it was new, it was also regarded as one of the freshest, most innovative office buildings of its era—not one reflecting an existing style, but synthesizing a balance between tradition and modernity. It attained historic stature as one of the most significant buildings of the era. The building's arcaded sidewalk along Vesey Street is a pleasant and appealing pedestrian amenity. Walker, only 34 at the time of the project, became a name partner of the firm, undertook other work for New York Telephone, and became one of the city's leading office building architects. The block at left was cleared for the World Telegram Building, a structure now remodeled as an office.

Founded in 1785, St. Peter's Church, the oldest Roman Catholic parish in the State of New York, leased land (which it later bought) at the southeast corner of Barclay and Church Streets. They laid the cornerstone of their first church October 5, 1785, using the building until *c.* 1836. A larger church was needed in the neighborhood (then residential), resulting in the construction from 1836 to 1840 of this magnificent Greek Revival edifice, designed by John R. Haggerty and Thomas Thomas. Mass was first celebrated in its basement September 3, 1837. Consecration was delayed until the 1885 centennial; by then, all debt was paid and some parishioners' objections to continued occupancy of the site (because of the area's change of character to a business district) were overcome by a declaration of John Cardinal McCloskey. The parish founded Catholic education in New York in 1800, closing its school in 1940. St. Peter's, seen on a contemporary prayer card, now serves the downtown business community.

THE CHURCH OF SAINT PETER
NEW YORK'S
OLDEST CATHOLIC PARISH

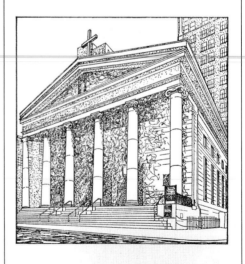

On the southeast corner of Barclay

The Trinity Court Building at 74 Trinity Place was designed by H.I. Oser and completed in 1927. The 25-story, 312-foot building was built in a T shape, extending to Greenwich Street. The office stands adjacent to the American Stock Exchange and overlooks the Trinity Churchyard. The image, a detail of a 1930s monochrome postcard of the church, also pictures a partial view of 2 Rector Street and a glimpse of the elevated rail structure.

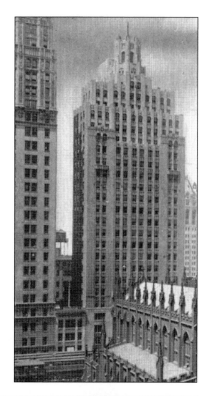

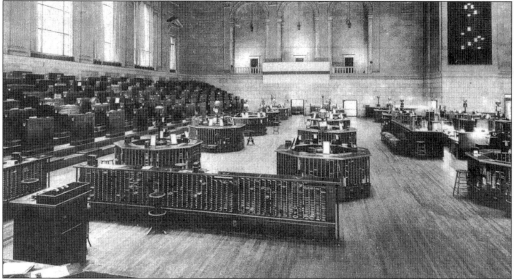

The New York Curb Exchange, named for its outdoor securities dealing practice (page 48), moved to new headquarters inside 86 Trinity Place and began trading there on June 27, 1921. Success brought expanded quarters that were completed in 1930, featuring a five-story trading floor of 20,023 square feet. The c. 1930s Albertype postcard provides a description on the back. The long counters in front are bond posts, while the octagonal desks handled stocks. The central station was at right center and telephone booths at left. A public gallery is at the rear. The Curb Exchange took its present name, the American Stock Exchange, in 1953.

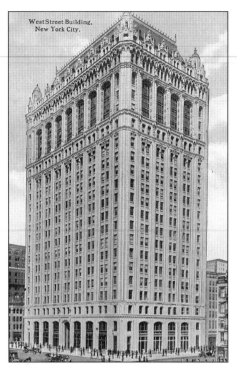

The West Street Building (at No. 90), designed in the Neo-Gothic style by Cass Gilbert, followed his Custom House (page 22) and preceded his Woolworth Building (page 72), for which this is a precursor. This view of the 24-story, 324-foot-high office from the corner of Albany Street depicts the tripartite design of a base, shaft, and capital, in the manner of a classical column. The limestone and terra cotta building was expected to be more effectively viewed from the water (or another high building), rather than the constricting surrounding streets. The exterior is little changed and is well worth a look. However, the once stunning lobby, finished with vaulted ceilings and Gothic decoration, was effectively lost in remodeling. One can walk through without realizing how radically the original Gothic interior has been altered.

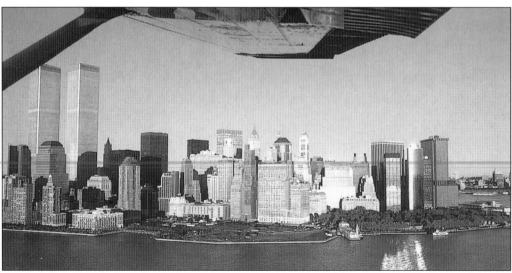

The old and new of the financial district are artfully blended by Gail Greig's camera. Part of the World Financial Center is seen, while the aerial view extends south to the tip of the island. The Whitehall Building (page 15) is the most prominent older structure in the center foreground. The new 60 Wall Street rises over it, while the Downtown Athletic Association is to its left. Pier A marks the southern end of Battery Park City, while the Custom House (page 22) is over it. Above the Custom House to the left is 2 Broadway, the dismal glass box that replaced the Produce Exchange. Some of the southern tip towers are better seen on page 18, but a later appealing addition, the curved glass facade of 17 State Street, is seen here reflecting the afternoon sun. (Courtesy of Gail Greig.)

Seven

AROUND CITY HALL
PARK ROW AND BROOKLYN BRIDGE

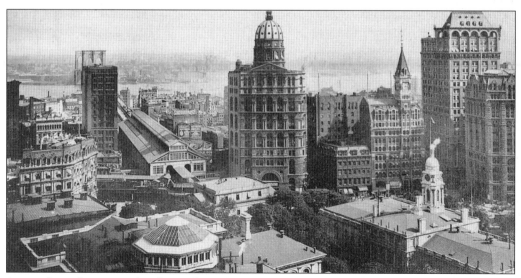

A view from the west side of Broadway, looking east, groups several buildings pictured in this chapter, including City Hall (pages 118 and 119). The round dome is atop the World Building (page 123), while the pyramidal clock tower is the Tribune Building (page 122). The Sun Building (page 128), at the southeast corner of Park Row and Frankfort Street, is between them. The Times Building, on the far right, and the American Tract Society Building, standing behind it, are also on page 122. A glimpse of the Tweed Courthouse (page 120) is in the foreground, while the mansard-roofed Staats-Zeitung Building is at left (page 121).

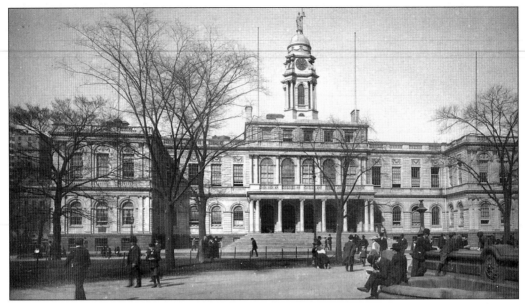

City hall, one of the city's finest Federal-style buildings and one of its most beautiful, was built from 1802 to 1811, the product of a collaborative design between competition winners Joseph Francois Mangin and John McComb Jr. The former is generally credited with the exterior, while the interior is believed to have been McComb's work. The original Massachusetts white marble cladding and brownstone base deteriorated and were replaced from 1954 to 1956 by Alabama limestone over a Missouri granite base. The north elevation was left bare in 1811 as City Hall was believed to be so far uptown that the rear would hardly be in public view. The postcard is a *c.* 1910 photograph.

George B. McClellan Jr., son and namesake of the Civil War general was born in 1865. He was educated at Princeton and New York Law School, entering local politics in 1889 and serving New York in a number of posts, including Congress. He was elected mayor in 1903, handily defeating his incumbent Fusion opponent, Seth Low, and again in 1905 for a four-year term, narrowly winning a tough contest with William R. Hearst. Thus, McClellan served during much of the postcard era. His visage is preserved on this *c.* 1905 Plastichrome postcard, taken by the notable Byron photographers.

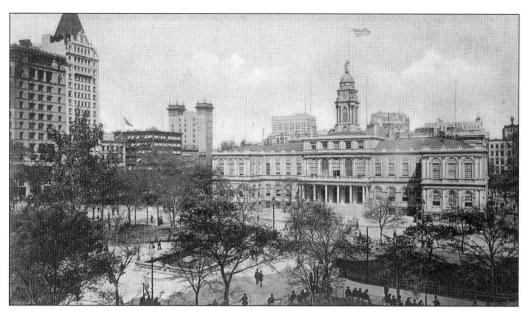

City Hall is seen with its park truncated by the post office, which provided an elevated perspective for the photographer. The area, *c.* 1905, was already sprouting high buildings, a trend that intensified over the next decade. City Hall's scale amidst its high surroundings continues to be one of its endearing characteristics. The nine-acre park was renovated in 1999 at a cost of nearly $30 million, a project that included installing a new Victorian-style fountain in a basin (visible in the foreground) that was designed in 1871 by landscape architect Jacob Wrey Mould. The project included various security installations that have constricted the former openness of the building.

A statue of Nathan Hale by Frederick Mac Monnies was presented to the city in 1893 by the Sons of the American Revolution. Yale graduate Hale, born in 1856 in Connecticut, was a captain in the American army in 1776. He was traveling around the city as it fell to the British, attempting to secure information on their forces, when he was captured out of uniform on September 21, 1776. He was found guilty of spying and hung the next day near Chambers Street. Hale became a hero of the revolution by virtue of the final remarks attributed to him: "I regret that I have but one life to lose for my country," the words inscribed on the base. The statue, once near Broadway and Murray Street, was moved in front of City Hall during the 1999 park renovation.

Civic Virtue was planned as a sculptural monument of progressive values. It was commissioned of Frederick Mac Monnies in 1909 for City Hall Park, but not installed until 1922. Support for public sculpture waned between those years and turned into vocal hostility with respect to this sculpture. Virtue is a stern-looking male, standing with sword over two prostrate females representing vice, the group a metaphor for the goal of good government. It was mounted in a large marble basin designed by Thomas Hastings. It was, perhaps, the city's most controversial art in its first 300 years, an era quieter than recent decades when controversy over art seems to have become routine. Varied opponents included women's groups and forces against the fading progressive ideals. The figure, nicknamed "rough guy" and "strong boy," remained in the park until exiled to Queens by Robert Moses in 1941, where the fountain was re-erected at Queens Boulevard and Union Turnpike, near Borough Hall.

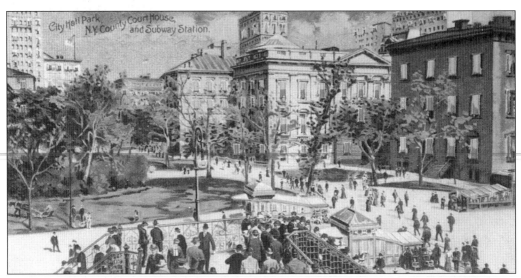

The New York County Courthouse began in 1861, located north of the City Hall at 52 Chambers Street. Its initial appropriation was $250,000, but corrupt politicians led by William "Boss" Tweed ran its cost to many millions by its 1878 completion. This gave the gray Massachusetts marble building, designed by John Kellus and Leopold Eidlitz, the widely used nickname "Tweed Courthouse." It functioned as a court until 1927 and was threatened often with destruction, but has survived to be appreciated for its architectural merits. A museum and visitor center are planned after completion of an extensive restoration, ongoing at the end of the 20th century. (Courtesy of Timothy J. McMahon.)

The juncture of Park Row, Spruce Street, and Nassau Street is known as Printing House Square (although it is missing its street sign) in recognition of the area as the former center of the New York newspaper publishing district. The sculpture of Benjamin Franklin by Ernst Plassmann was unveiled January 17, 1872, presented by Albert DeGroot to the press and printers of New York. Also seen here are, clockwise from upper left: Pulitzer Fountain, Central Park; William Cullen Bryant, Bryant Park; Nathan Hale, City Hall Park (page 119); Maine Monument, Columbus Circle; Giovanni Verrazano, Battery Park; 7th Regiment Monument, Central Park; and John Ericsson, Battery Park (page 13).

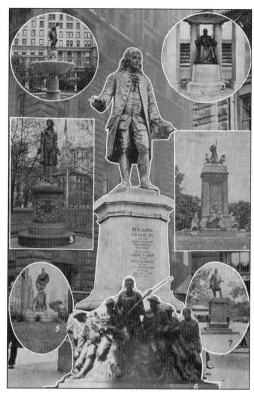

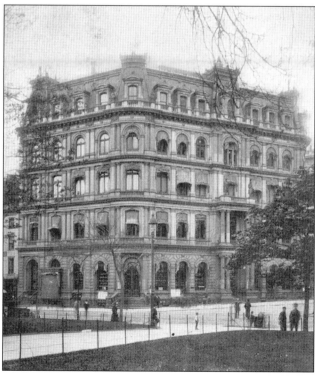

The *New Yorker Staats-Zeitung*, a German language newspaper owned by Oswald Ottendorfer, built this five-story headquarters northeast of City Hall (see page 117) on an irregular plot at Chambers, Centre and Chatham Streets. The building was completed in 1872 to a design by Henry Fernbach. Note the third-floor balcony flanked by statues of Johannes Guttenberg and Benjamin Franklin, sculpted by Ernst Plassmann. The building was demolished *c.* 1908 for construction of the Brooklyn Bridge Terminal and the Municipal Building.

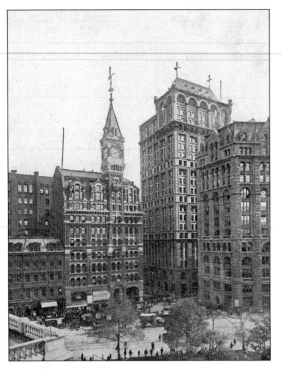

The Tribune Building on the northeast corner of Nassau and Spruce Streets, designed by Richard Morris Hunt and built between 1873 and 1875, was the first tall building in a neighborhood that emerged as "newspaper row," following the construction of the first Times Building on the site at right. The bold, innovative design, its tower borrowing from the campanile of the late-13th-century Palazzo Vecchio in Florence, Italy, made a striking statement at its prominent locale. Its 260-foot height made it the city's tallest commercial structure. A later enlargement gave the building a U shape, embracing the extension in the left background behind the Sun Building on the corner of Frankfort Street. The building was demolished in the 1960s for construction by Pace University. The New York Times Building is at right in its state as built and at bottom, as expanded in 1905.

The *Times* was the first newspaper to build adequate quarters designed for its own needs. They completed a five-story building in 1857 at 41 Park Row, its juncture with Spruce and Nassau Streets. George B. Post planned a 13-story replacement for the same site, which was built around the existing structure without interrupting operations. His Romanesque Revival design, built with Indiana limestone over a Maine granite base, seen at top, was completed in 1889. Alterations designed by Robert Maynicke created its present appearance (seen in this *c.* 1910 Detroit Publishing postcard) and embraced the removal of the mansard and the erection of three full floors. The changes were completed in 1905, shortly after the *Times* moved to Forty-second Street. The building is now owned by Pace University. The Romanesque 23-story, 291-foot American Tract Society Building at 150 Nassau Street was designed by Robert H. Robertson, completed in 1895, and built for rental income after this printer of religious publications moved to East Twenty-third Street. The building, distinguished by its arcaded loggia, is undergoing extensive renovations in the early 21st century.

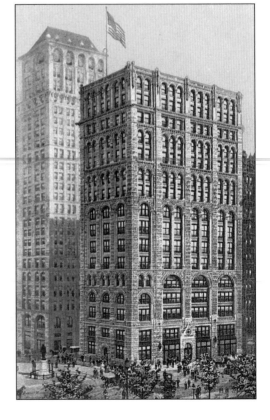

The *World*, founded in 1860 by Alexander
Cummings of Philadelphia, was purchased
by Joseph B. Pulitzer in 1883. This 26-
story, 309-foot-high headquarters at 53
Park Row near the northeast corner with
Frankfort Street was designed by George B.
Post, the winner of a competition. Pulitzer,
who built it from 1889 to 1890, claimed to
have been an influence to its design
aspects, including the grand three-story
entry and notably the addition of the gold
dome, reminiscent of Michelangelo's dome
for St. Peter's. He had taken a respected,
but little-read publication and turned it
into a quite successful mass-market paper.
The building was to reflect that success,
outshine the competition (notably the
Tribune next door), and represent
corporate stature. The *World*, which
foundered after his 1911 death, was
bought by Scripps-Howard in 1931 and
merged into their *Telegram*. The building
survived into the 1960s as an office, when
it, too, was demolished for
Pace construction.

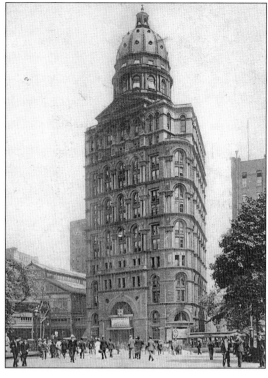

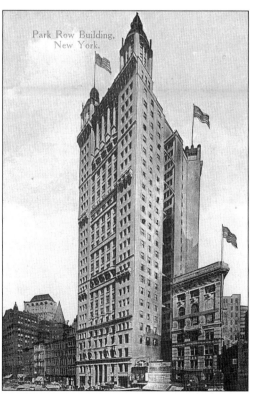

The Park Row Building at No. 15 overshadows
neighboring structures now as it did when
completed in 1899. Designed by Robert H.
Robertson, the 32-story, 386-foot-high
building, the tallest office in the world from
1899 to 1908, rises straight up from its mid-
block location between Beekman (left) and
Ann Streets. It was built for rental income by
the Ivins Syndicate and, when new, was also
known as the Syndicate Building. Four
idealized female figures, sculpted by J. Massey
Rhind, stand on massive brackets at the third-
floor level. The twin towers offer visual
stimulation to the plain facade. This *c.* 1910
postcard shows one light court, part of an
irregular plan that packed in many small
offices, their number reaching a reported 950,
and a street now greatly altered. It appears
that only one of the old five-story buildings
remains. New construction at the Ann Street
corner is ongoing at the beginning of the 21st
century. Expansion space for the audio-
electronics retailer now occupies much of the
block. The pointed tower in the background
is 5 Beekman Street.

The photographer's aim in 1900 was directed to the skyscrapers, the St. Paul Building on the left, and the Park Row Building. However, the foreground at John and William Streets is more interesting, as the area would be transformed by office towers for the insurance industry over the next three decades. The Detroit Publishing Company copyright is 1901, while the postcard dates a few years later. However, the dating aid is the McKinley-Roosevelt campaign banner, at bottom, erected by the Drug, Paint, Oil, and Chemical Trades Campaign Club (visible in the uncropped photograph), which reveals the neighborhood's character before the spreading financial services occupancies replaced them. Underneath the Park Row Building is the Bennett Building (page 85), while to its left is 90 Nassau Street at the southeast corner of Fulton Street, which runs along a line formed by the two buildings. The vantage was probably from the Woodbridge Building at 100 William Street, demolished c. 1970.

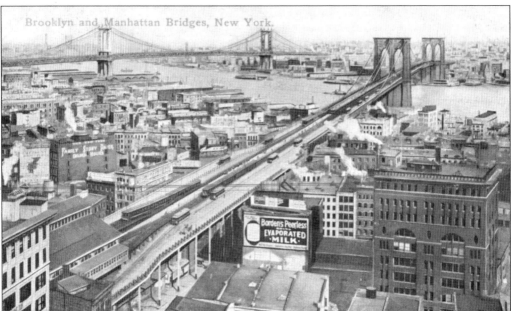

Each improvement of transportation between New York and Brooklyn tended to make the latter more of a suburb of the former. Once rival cities, the completion of the Brooklyn Bridge in 1883 boosted enormously Brooklyn's role as bedroom for Manhattan. Two additional bridges followed: the Williamsburgh Bridge in 1903 and the Manhattan Bridge in 1909, the latter at top. The high-rise building at right is the Healy Building at the northeast corner of Gold and Ferry Streets. This area then included a leather industry, one established there since colonial days, which occupied the buildings in the foreground.

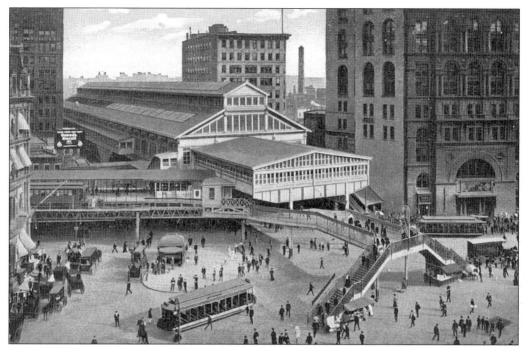

The introduction of one fare trolley service on the Brooklyn Bridge accelerated Brooklyn's role as a suburb. The elevated line spur at left was demolished in 1945, while the trolley enclosure survived for some additional years. The World Building is at right, while a sliver of the *Staats-Zeitung* Building is at left. Note the signage, including a baseball scoreboard at right, which drew throngs at World Series time, and the Uneeda Biscuit sign at left, the brand Nabisco cannot kill.

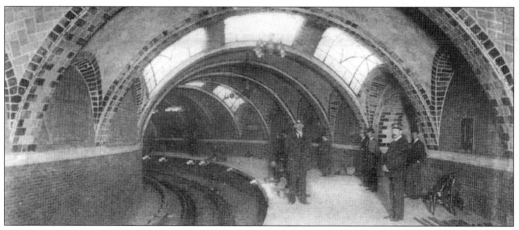

The city's first subway opened October 27, 1904, running from City Hall to 145th Street, with Mayor McClellan at the motorman's controls. Its origin was a 240-foot-long station, built under City Hall Park in a long loop that enabled trains to turn around. The line's stations were planned by the system's chief engineer, William Barclay Parsons, and designed by Heins & LaFarge. Vaulted ceilings, skylights, chandeliers, and fine tiling made the City Hall station the most ornate. Located only a few hundred feet from the much more heavily used Brooklyn Bridge station, the City Hall station was closed in 1946. However, the station survives, but proposals for its use as a subway museum have not been carried out, in part for noise and security concerns.

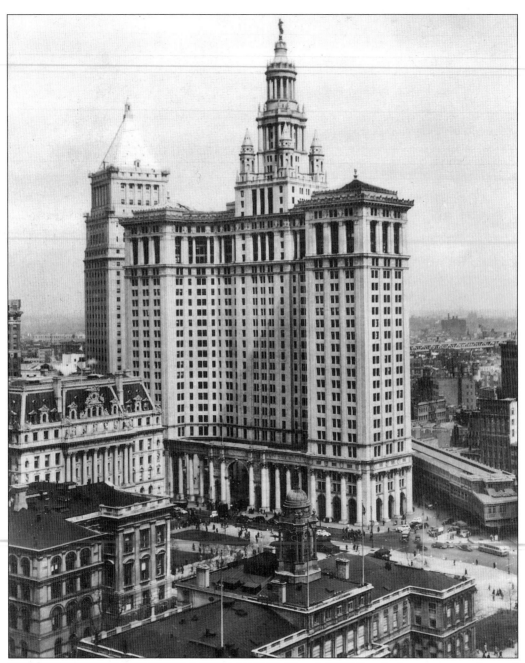

The four great city buildings, each described elsewhere, are shown in relation to one another and to this book's northern boundary, Chambers Street, which formerly passed through the Municipal Building. Standing on a copper globe atop this building is Adolph A. Weinman's statue *Civic Fame*, a 20-foot-high female figure in flowing robes holding a sprig of laurel in her right hand and a mural crown of five parapets (symbolic of the five boroughs) in her left. The gold pyramidal roof is the top of the United States Courthouse, designed by Cass Gilbert and Cass Gilbert Jr. It was completed in 1936 at Foley Square and Pearl Street. The photographic postcard dates *c.* 1940s.

The Beaux-Arts Hall of Records at 31 Chambers Street, the block between Elk and Centre Streets, was built from 1899 to 1911. It was designed by John R. Thomas, who died in 1901, with Arthur J. Horgan and Vincent J. Slattery, who completed the project. The building, clad in Maine granite and begun the year after the consolidation of New York, reflects the pride the newly joined five counties could take in their new government. The building houses a variety of New York City records, notably real estate transactions. There are two court rooms on the fifth floor, with the building given a hyphenated name in 1963 preceded by "Surrogates Court." Numerous sculptural decorations detail the city's history. The interior is richly decorated. One feels a rarely encountered governmental grandeur on entering the double height marble lobby, an experience well worth a visit. The facade is unchanged, but four iron light stantions and two large stone statues have been installed at the entrance.

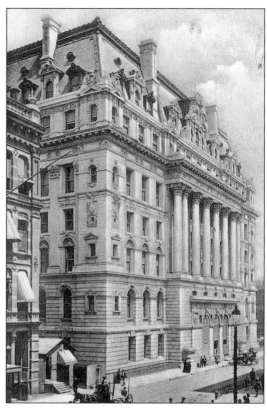

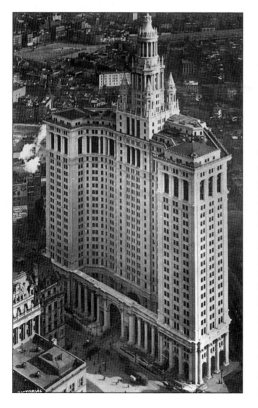

The Municipal Building—completed in 1914 from a design by William Mitchell Kendall, a partner of McKim, Mead & White—was the largest structure of its kind when completed and posed one of the most difficult foundation jobs. The flattened U-shaped building rests on 116 pneumatic caissons sunk to bedrock, in some places 260 feet deep. The building, containing about 600,000 square feet of floor area, is 450 feet from east to west. Its 580-foot height includes the *Civic Fame* statue, which had not yet been mounted, leading to the conclusion that the building pictured is new. The view looking northeast may have been taken from the Woolworth Building. The background contains the future Civic Center, Chinatown, and the approach to the Manhattan Bridge.

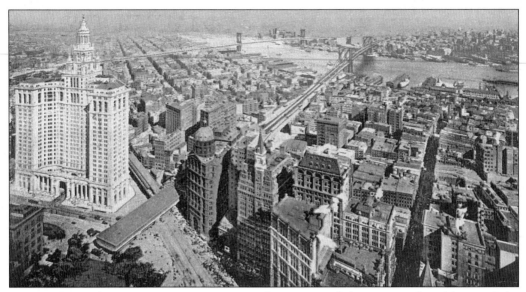

The buildings of newspaper row are seen in the context of the Municipal Building and the manufacturing district to their east. Printers and stove manufacturers also occupied the buildings near the East River. Storage vaults filled the space under the Brooklyn Bridge approach. The north–south streets passed through the support structure, creating appealing vistas throughout the arched openings. The area north of the Brooklyn Bridge has been transformed by post-WWII construction, much of it by the Gov. Alfred E. Smith Houses and Knickerbocker Village. Beekman Street is at right. Much of the surrounding area between it and the bridge has been developed by Pace University and Beekman Downtown Hospital.

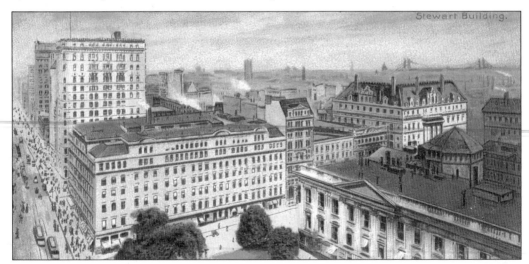

The Tweed Courthouse is at right (page 120), while Chambers Street runs across this *c.* 1903 J. Koehler postcard. At left is the A.T. Stewart store, an Italianate-style white marble building designed by J.B. Snook and Joseph Trench and completed in 1846 at 280 Broadway on the site of Washington Hall, which had burned in 1844. It is one of New York's most important buildings, as the city's first department store and as the first Italianate building in America. The building was bought by William T. Dewart, president of the *Sun*, which published there, erecting a clock still on the corner of a building little changed since this image.